JEWELERY
MAKING

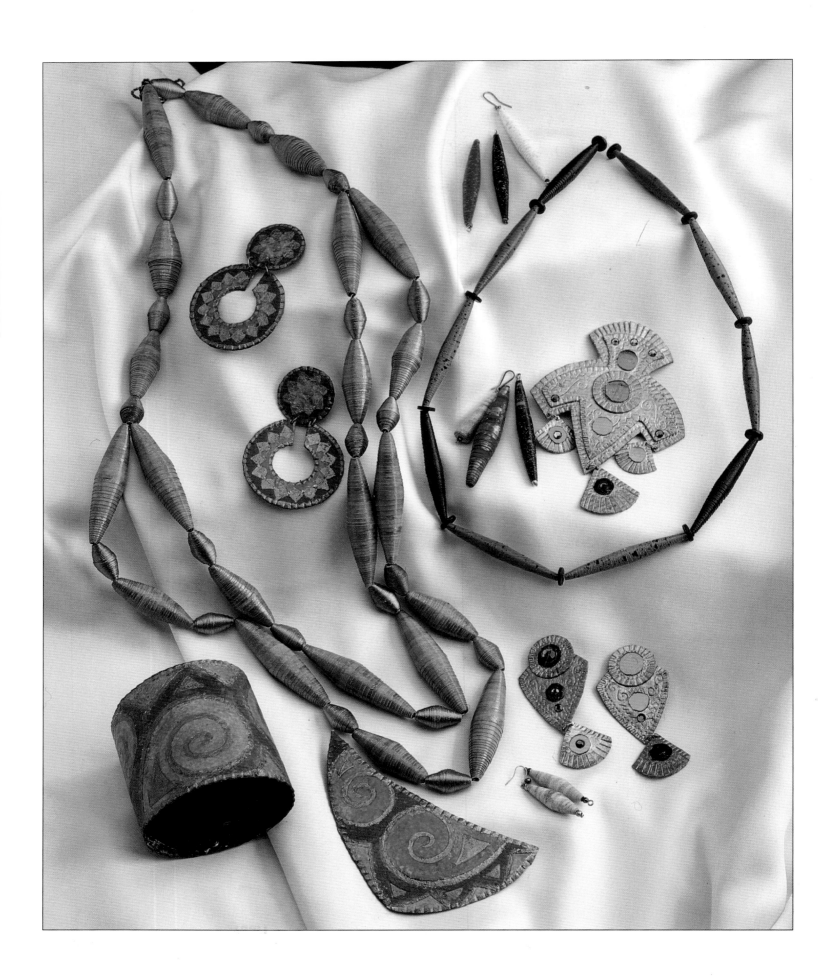

JEWELERY

M A K I N G

GILL CLEMENT

CHARTWELL
BOOKS, INC.

Published by
Chartwell Books, Inc.
A Division of Book Sales, Inc.
Raritan Center
114 Northfield Avenue
Edison, NJ 08818
USA

ISBN 0-7858-0177-4

Printed in Italy

Acknowledgements

Introductory photographs courtesy of
The Bridgeman Art Library.

Thanks to Paperchase, London for allowing us to use
their paper for the jacket.

The author wishes to thank Annabel and Nicolette
Trodd, Rachel Williams for her help with the projects,
Simoné Robbins for help with the wedding project and
Adam England for his assistance with the writing.

CONTENTS

INTRODUCTION

From earliest times, mankind has felt the need for self-adornment in one form or another, and there have been various reasons for this other than the desire to beautify. Amuletic and powerful symbolism has been attributed to jewellery even in its earliest forms.

Man has always recognized the intrinsic beauty of the natural objects which surround him in his environment, not least gold and precious minerals. But even before the use of metals was developed, man felt the superstitious need to protect himself from the natural forces of evil which lurk outside.

Little carved stone pendants of animals have been found as early as 3000 BC in Mesopotamia. These appeared to have been worn as protective amulets but at the same time were simple though highly decorative objects in their own right.

This magical impetus and urge to decorate the body must also have given rise to body-piercing and tattooing, both of which have suffered no loss of popularity down the ages. Indeed, they have proliferated and today piercing has spread to other parts of the anatomy. It is not only the humble ear lobe that now must be adorned!

Similarly, tattooing is as popular as ever and it is no longer unusual to see a body completely covered with the most extravagant of designs. This need to embellish the body and improve a little on nature seems to have always been a primitive force in mankind.

The ancient Britons painted

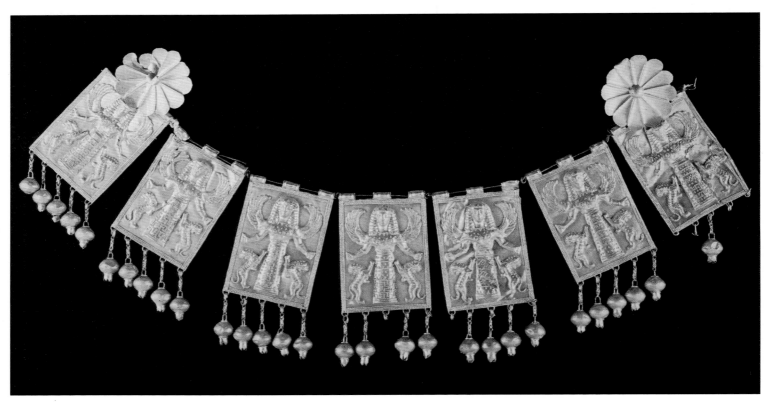

ABOVE

Seven gold plaques worn across the chest with rosettes pinned at the shoulders depicting Artemis and lions from Camirus, Rhodes. (660-700BC)

themselves from head to toe in blue woad, no doubt to appear more fearsome and to terrify their adversaries on the battlefield. But at the same time, one cannot help feeling that they enjoyed the rather interesting effect it produced.

At every time in history, self-enhancement has been an important preoccupation, directed as much to the business of attracting the opposite sex as to the feelings of pleasure and self-esteem experienced as a result. This is no less important today when outward trappings and designer labels are very much to the fore and have even led, in extreme cases, to the phenomenon of the shopaholic.

The search for joy and happiness plays an important part in society. Without these emotions, it is unlikely that the human race would have been around for so long. A person who can stimulate such strong feelings in his fellow man by the works of art he produces must always be a valued and admired member of society.

The craftsmen who produced magical jewellery in ancient myth and legend, from Freya's fiery necklace to

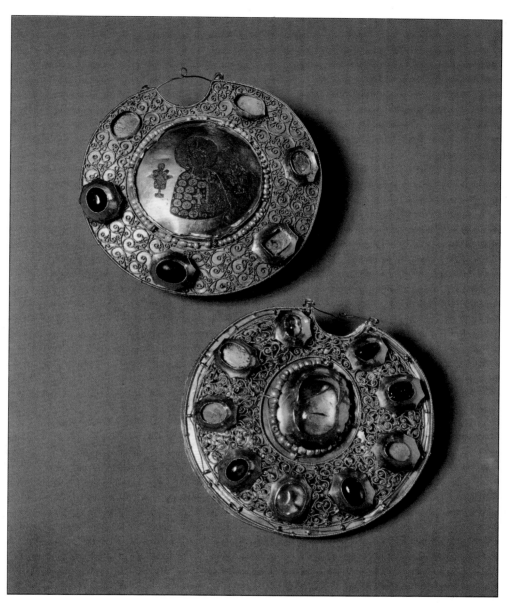

ABOVE
Kolt Medallion, gold set with pearls and jewels and with filigree, enamel, granulation and cloisonné decoration, Ryazan, 12th century.

Hephaistos's sceptre, produced for Agamemnon in Homer's *Iliad*, never fail to stir the collective imagination.

It is sad that precious jewellery, like antique furniture and Old Master paintings, has come to be treated as a mere investment and that its original purpose, that of inspiring wonder and joy, should have been lost in the transaction. 'All that glisters is not gold'. It is possible to know the price of everything and the value of nothing.

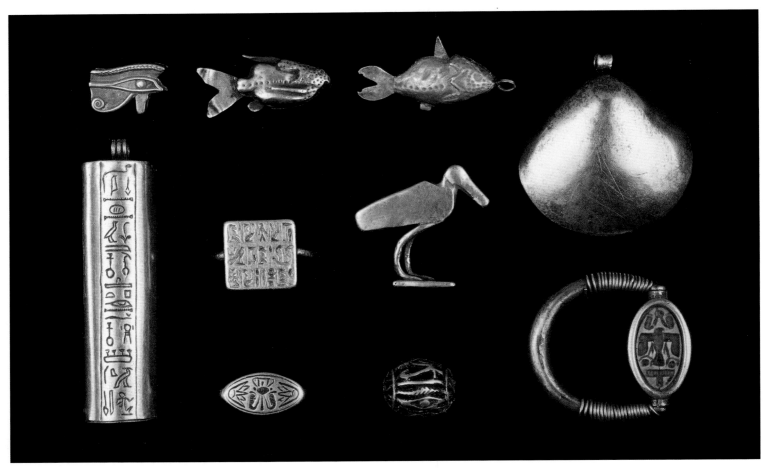

ABOVE
Rings, pendants and amulet holders, Egyptian, 2nd century BC (gold and silver)

It is not clear when jewellery first came to be used as a means of displaying wealth or social status, but this manifested itself in many ways from necklaces of flowers, teeth, nuts, shells, seeds and beads to the great feathered headdresses denoting chieftainship. But even in early times it was beginning to be recognized that scarce or rare materials were desirable for this purpose. When shells came to be used as currency, they were strung around the body as a display of personal wealth and managed to look quite attractive at the same time.

Once metalwork techniques were discovered, gold became the most desirable of all metals although there were some periods in history when silver was more highly prized. Gold was bright, beautiful, virtually indestructible, and became highly cherished as a symbol of the sun as source of light and life.

Gradually, precious stones and minerals came to be incorporated to produce valuable forms of jewellery. Gemstones were seen to possess symbolic and mystical qualities of their own and connected to the zodiac and the casting of horoscopes. Many people today will choose a precious stone which has been linked for generations to the time of the year in which they were born,

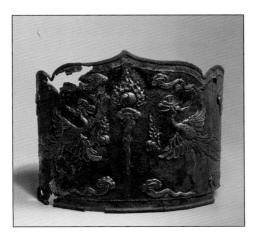

beauty and power. With the advent of metals and the increasing discovery of precious minerals, these objects grew in beauty and intricacy and the ingenuity of their makers increased.

By the time the Romans arrived, bearing in mind the tools available to them, the jewellery craftsmen were certainly as skilled as the craftsmen today. In this span of time up to the early 19th century, however, jewellery still had a 'one off' quality. There was still the feeling that a piece of jewellery was the work of a craftsman and therefore, unique to its owner and a reflection of his or her personality.

It was not until the advent of mass-production in the 19th century that jewellery became

at the same time professing not to believe in 'all that'.

A ring, because of its circular, unending form, is still the most potent symbol of undying love, while the diamond, because it can never be destroyed, is seen in the same light, as a symbol of eternity.

Jewelled artifacts are widely used in religious ceremonial as fitting receptacles for sacred relics and the body and blood of Christ himself in the Christian mass. One only has to travel to the East to see the massive golden images of the Buddha on display.

It all began when primitive man began to make articles of self-adornment for his own personal use and chose objects from around him for their

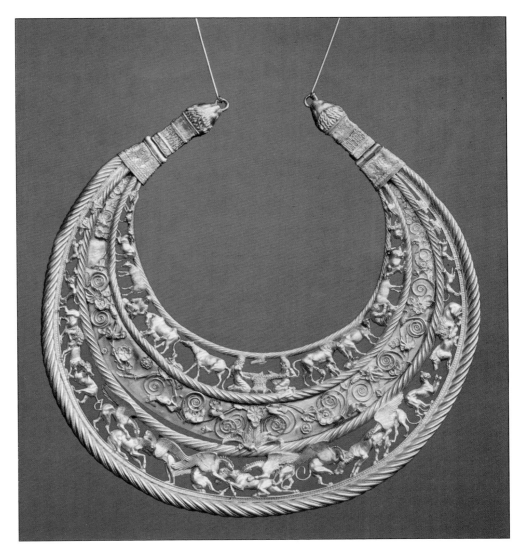

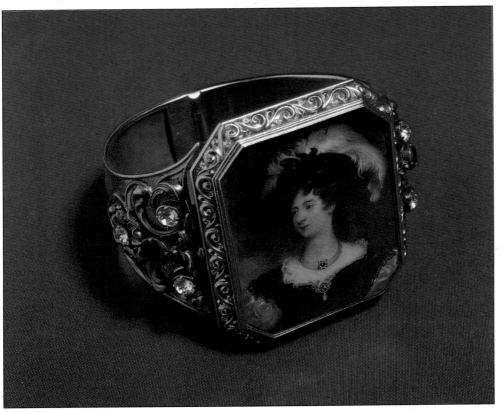

ABOVE
Bangle set with portrait miniature of Charlotte, Duchess of Northumberland,
by William Essex

available to all. To a certain extent, this was when all the fun disappeared from owning jewellery. What was the point of wearing a piece if thousands of others were wearing the same thing?

There still existed, however, a market for individual pieces of high-class jewellery among the very rich, but mass-production inevitably led to a general lowering of standards. Indeed, one could say that during the Industrial Revolution and up to the later stages of the 20th century, jewellery ceased to be made; it was manufactured.

Recently, however, the emphasis has shifted back to the value of craftsmanship and individual design. The importance of the individual has been re-emphasised in our society and many of us are no longer preoccupied with the material worth of a piece of jewellery.

There is a growing awareness that an infinite variety of materials is possible and the use of expensive materials is on the decline. Gold, silver and diamonds have been replaced by wood, paper and leather. The lower the monetary value, the more individual the piece acclaims itself to be.

Once again, jewellery has risen to the level of art form, and designers proliferate taking their inspiration from organic forms and the most unexpected sources. Jewellery goes hand in hand with the fashion industry and this has never been more interesting or innovative.

Many people have realized that if you want something different you can make it yourself. Gill Clement is an example of this new breed of artist-jewellers who hope to encourage this idea. It is the aim of this book to show how you, the amateur jeweller with strong feelings of individuality and a talent which may be laying dormant, can produce jewellery which is personal to you and satisfying to you and which all the money in the world just cannot buy.

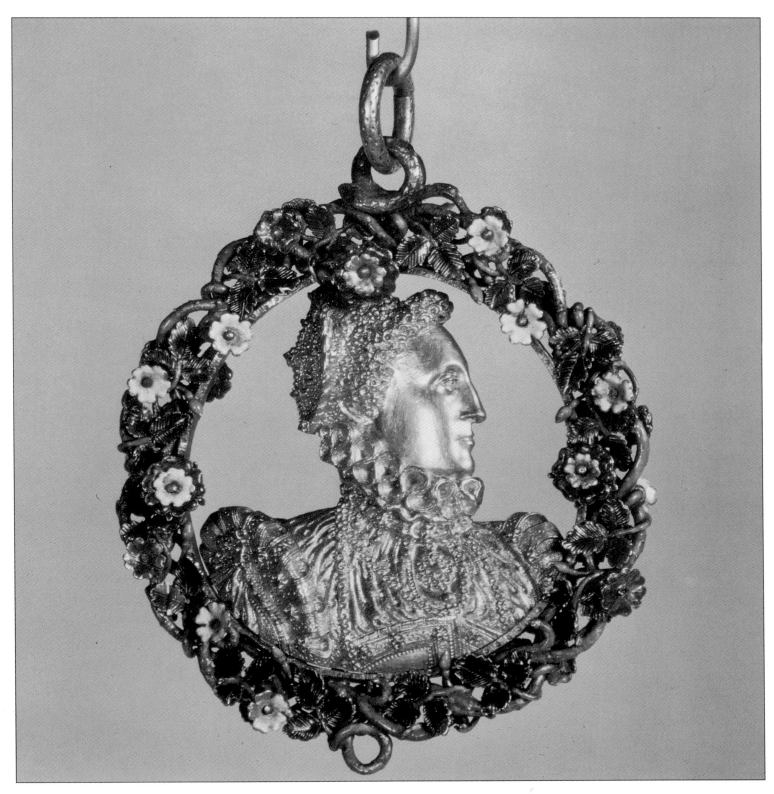

ABOVE

Elizabeth I (1533-1603) Phoenix Jewel.

NEXT PAGE

The Cheapside Hoard, contents of a London Jeweller's Shop which had probably been buried before the Great Fire of London, 1666. Discovered in the River Thames.

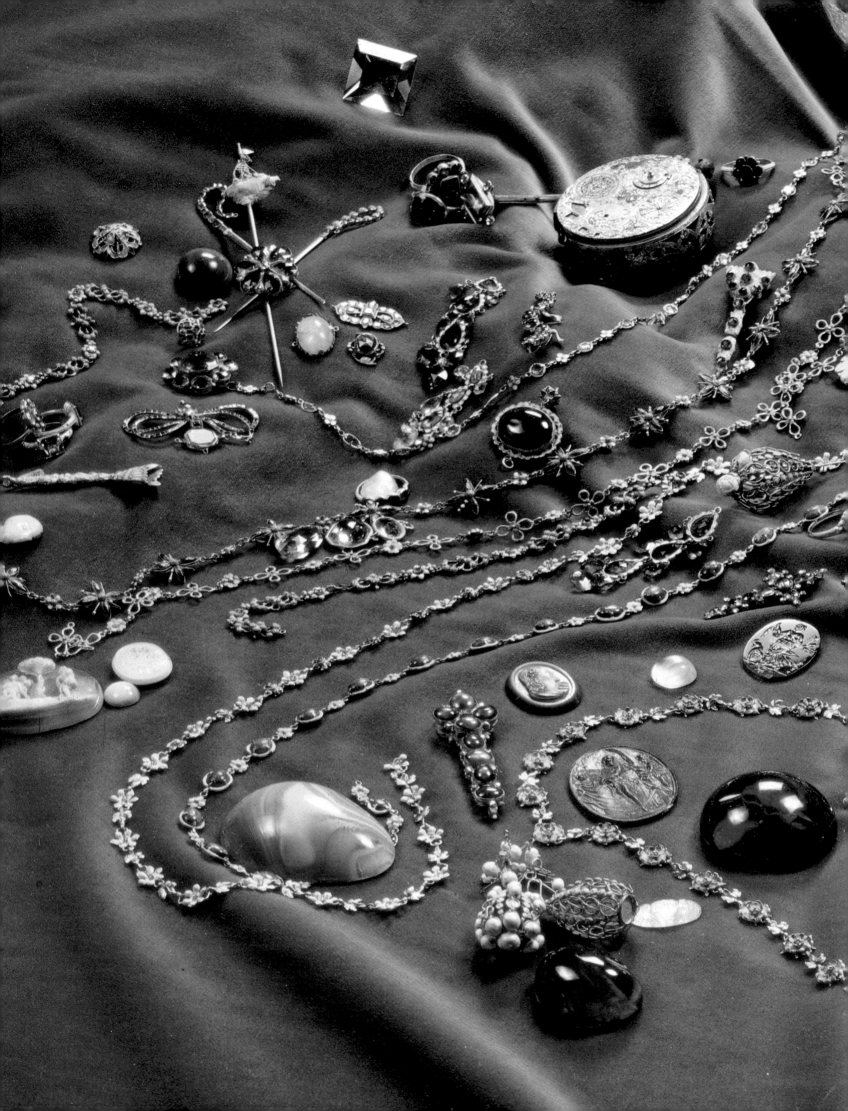

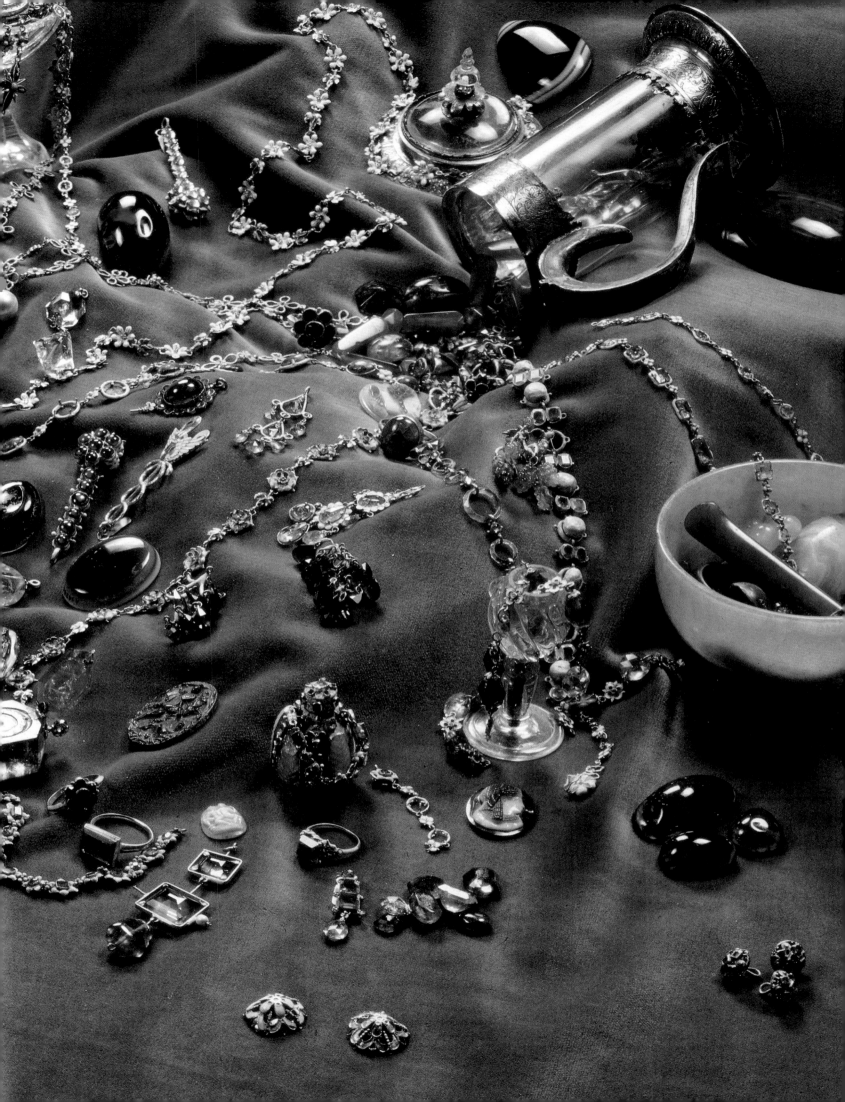

DESIGNS IN WOOD

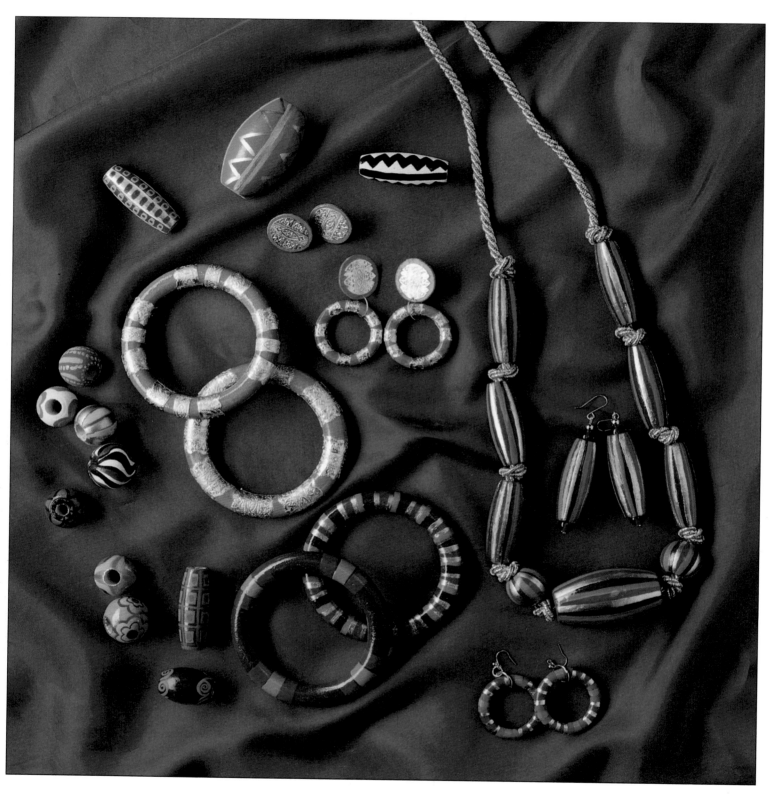

ABOVE

Customize wooden beads to your own taste. This picture shows some different treatments of wooden beads, painted with both enamel for a shiny finish and acrylic for a matt finish. Large wooden curtain rings are painted to wear as bangles.

DESIGNS IN WOOD

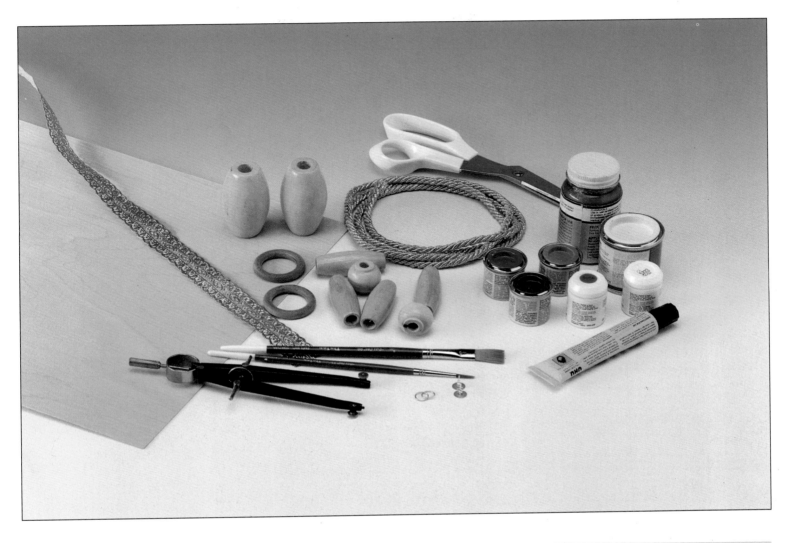

Materials

For this project you will require 1mm thick plywood, white acrylic paint, red, purple, orange and gold enamel paint, all from hobby shops. You will need small wooden curtain rings and gold cord from large department stores or soft furnishers. You will need wooden beads, jump rings, earring posts, thick and thin paintbrushes from craft shops.

From DIY stores, you will need strong glue and sandpaper. You will also need some gold cake decoration paper available from supermarkets or confectionery suppliers, scissors and a compass.

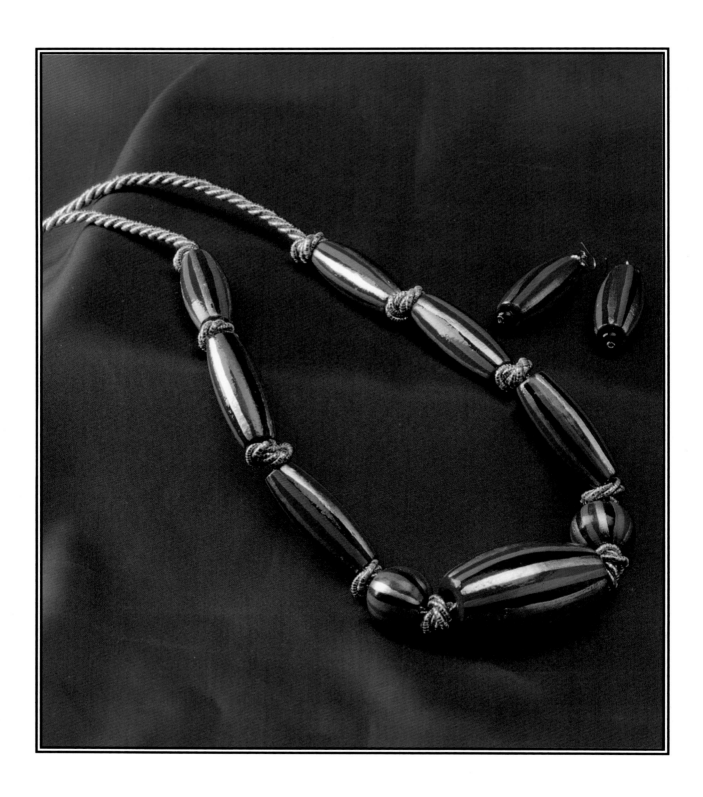

WOODEN BEADS

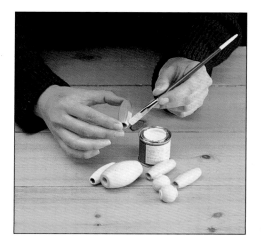

3 Paint the purple stripes and leave to dry. Then paint the orange stripes and leave to dry.

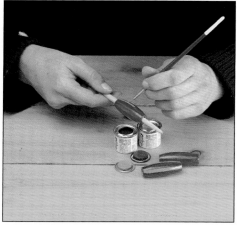

1 Using the thick paintbrush, paint each bead with white matt enamel primer and leave to dry.

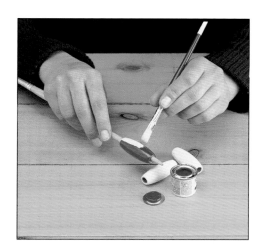

2 Place the beads on to dowelling or the handle of a brush (to hold them steady) and paint them with enamel paint of your choice, in this case, red.

4 Paint on the gold stripes and leave to dry for approximately 30 minutes.

5 Thread beads on to the gold cord and tie a knot between each one. Knot the ends together. Remember to use a longer piece than required as knotting takes up a lot of extra cord.

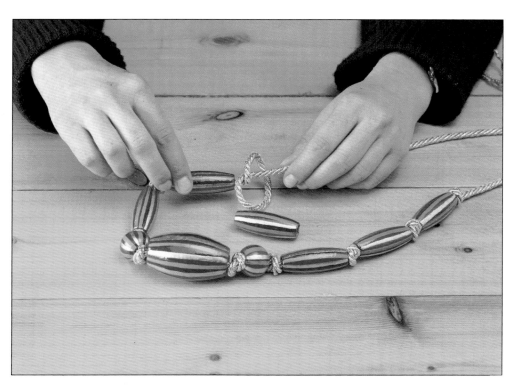

CURTAIN RING EARRINGS

1 *Using the compass, mark out two circles 2cm (3¼″) in diameter on 1mm thick plywood. Cut them out with good scissors. Smooth out the rough edges with fine sandpaper.*

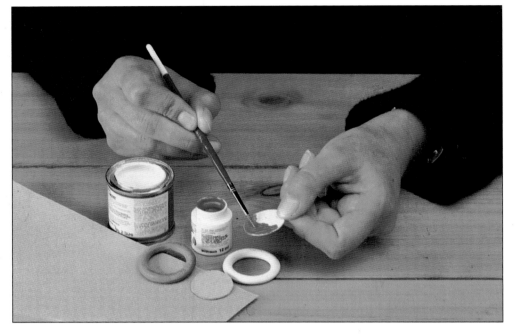

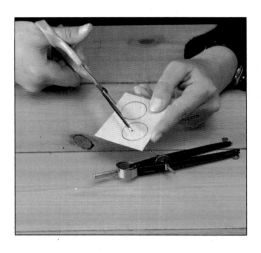

2 *Paint wooden circles and curtain rings with white matt enamel primer. When dry, paint with cerise acrylic paint and leave until thoroughly dry.*

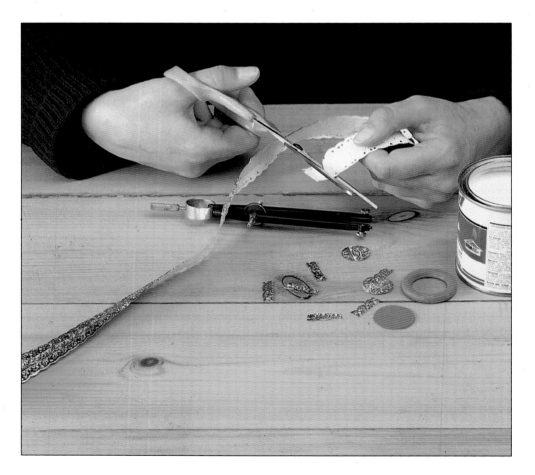

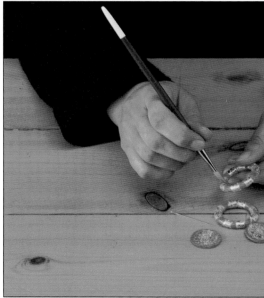

3 *Cut out strips of gold cake decorating paper and two circles smaller than the diameter of the wooden circles.*

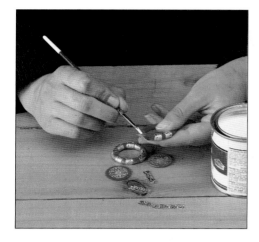

4 Paint glue on the back of the gold strips and place onto the curtain rings. Glue gold circles onto the wooden discs. Leave to dry.

5 Varnish surfaces with acrylic satin varnish. Allow to dry. Repeat approximately ten times until a thick layer is built up.

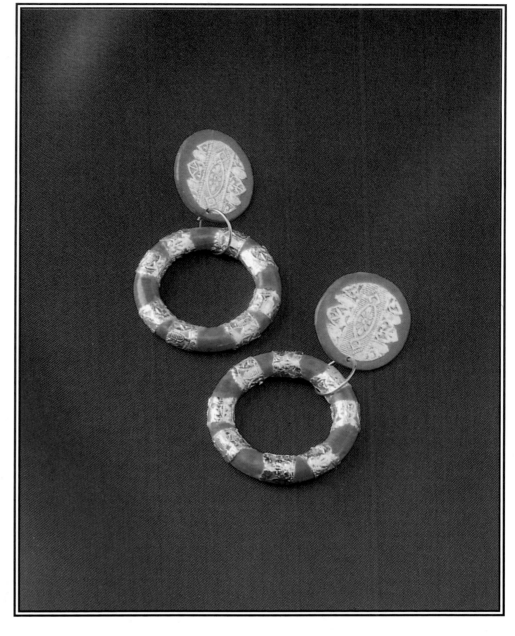

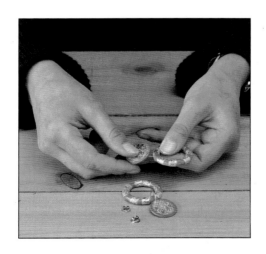

6 Using a sharp, thick needle, make holes in the wooden discs and join to curtain rings with a large gold jump ring. Glue on earring post with strong adhesive.

MODELLING CLAY

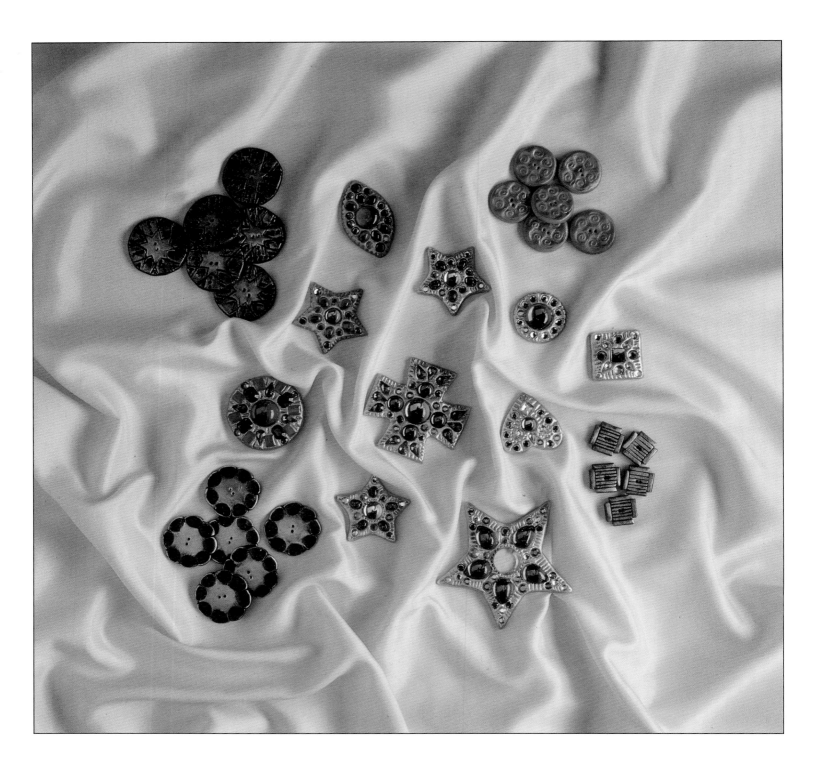

ABOVE

Illustrated above are embossed buttons and earrings. The buttons are made from modelling clay fired in a
domestic oven. The brooches and earrings are made from two-part modelling clay built up on a wooden base
and decorated with glass stones and beads. The final touch is added by rubbing metallic gold powder onto the
surface of the jewellery.

M O D E L L I N G C L A Y

Materials

For this project you will require 1mm thick plywood, two-part modelling clay (two-part epoxy putty), medium paintbrush,

glass stones, and jewellery findings, all available from hobby shops. You will need metallic gold powder from art suppliers.

You will also require a pair of tin snips and a medium-sized sewing needle.

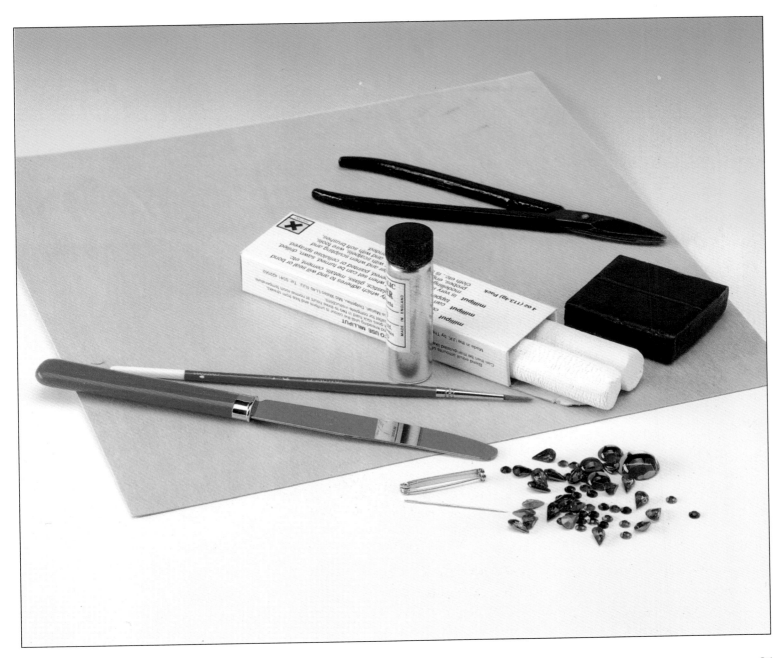

C L A Y B U T T O N S

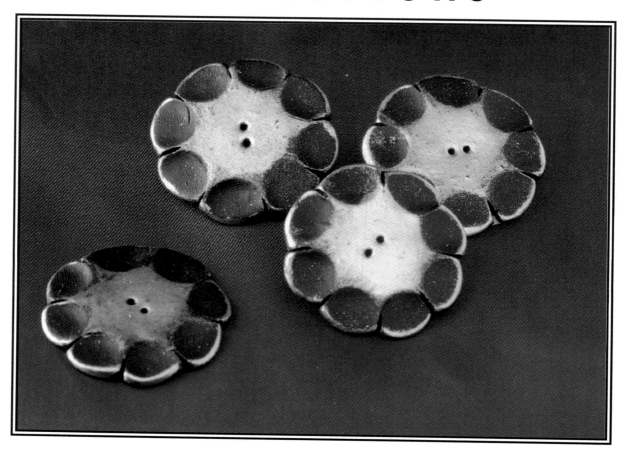

1 *For this project you will require oven-hardened clay. Cut clay into equal segments for required number of buttons. Knead clay until soft. Roll into a ball and flatten into a circle.*

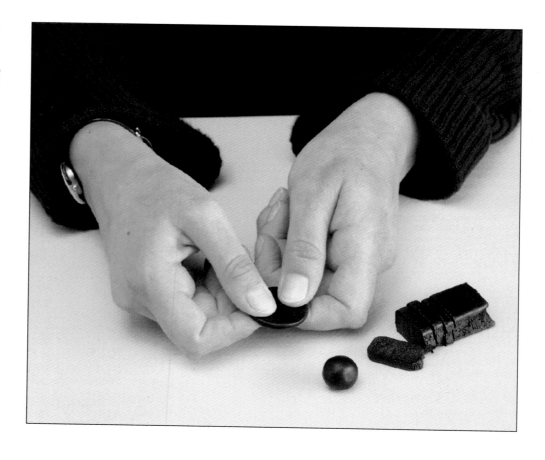

CLAY BUTTONS

2 Mark circle by making indentations with finger. At the same time, score with a knife. Repeat around circumference.

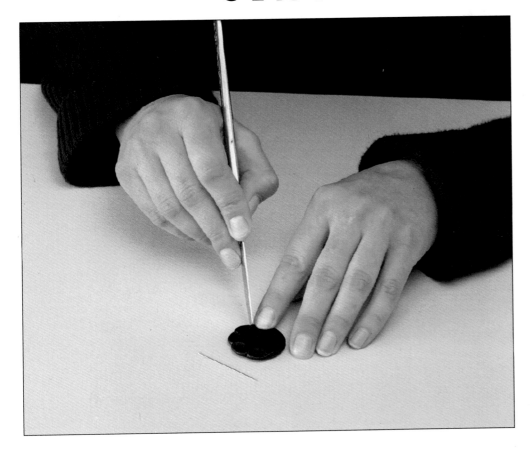

3 Rub on a small amount of metallic gold powder to enhance the centre and edges of the button. Make two holes in the centre with thick sewing needle. Fire in a domestic oven according to the manufacturer's instructions.

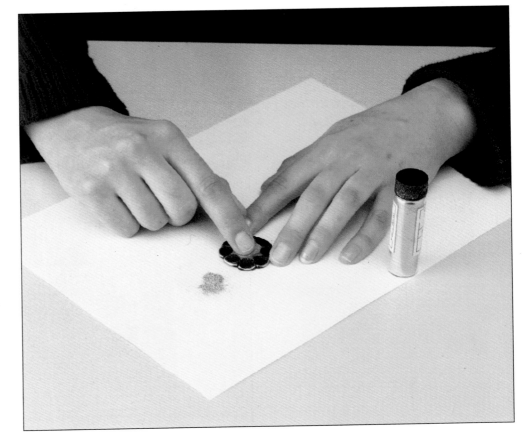

CLAY BROOCH

1 *Mark out a cross on 1mm thick plywood using the template in the back of the book.*

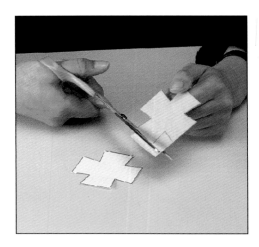

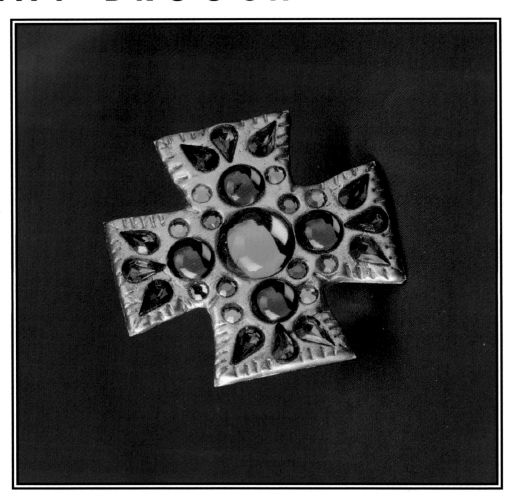

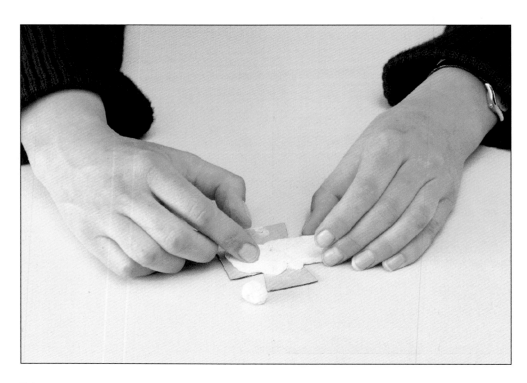

2 *Mix the two-part modelling clay together following the manufacturer's instructions. Mould on to the wooden template.*

This method is very effective and can easily be adapted to earrings, necklaces and bracelets.

CLAY BROOCH

3 *Position stones and push into modelling material*

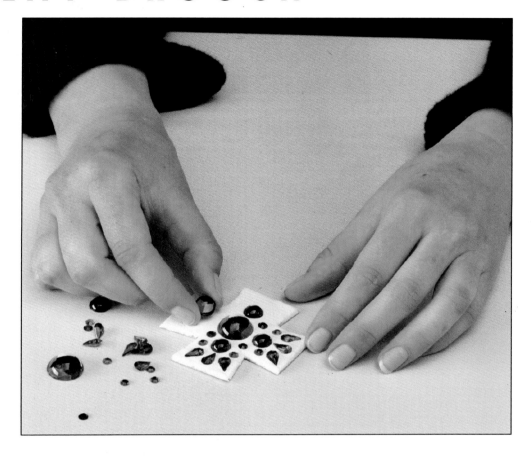

4 *Brush on the metallic gold powder, making sure that the entire surface of the brooch is well covered.*

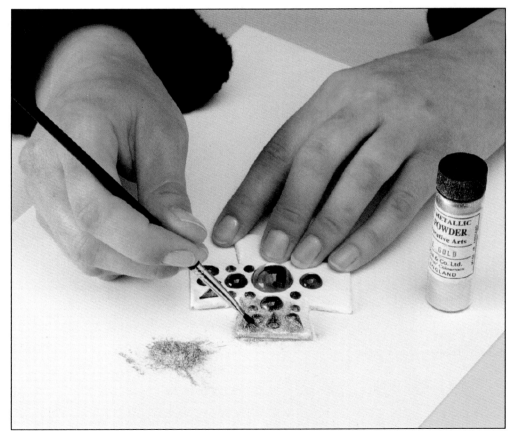

LUXURIOUS SUÈDE

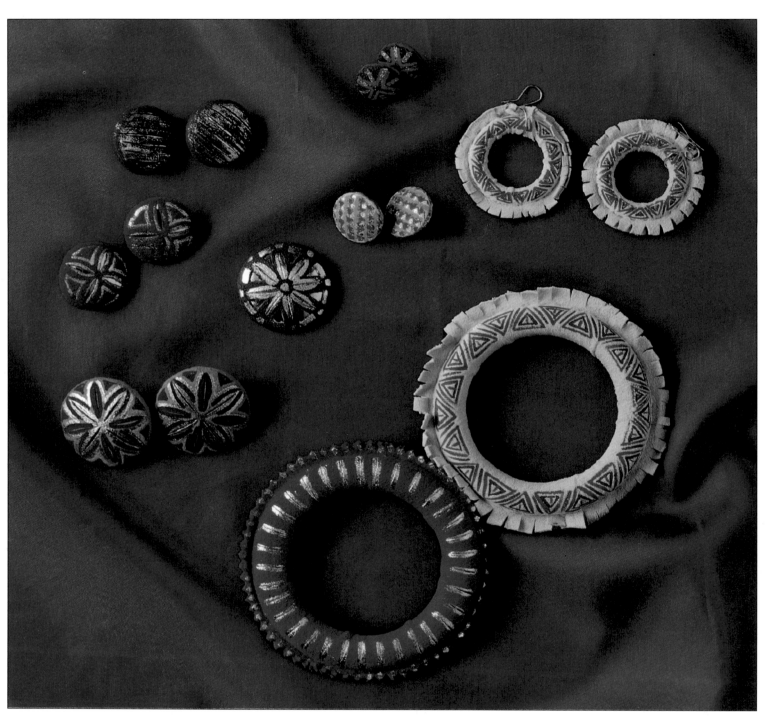

ABOVE

This picture shows a selection of earrings and bangles. The round earrings are made from suède-covered buttons, the suède having been cut and painted. The hoops and bangles are painted suède-covered curtain rings with the edges fringed.

LUXURIOUS SUÈDE

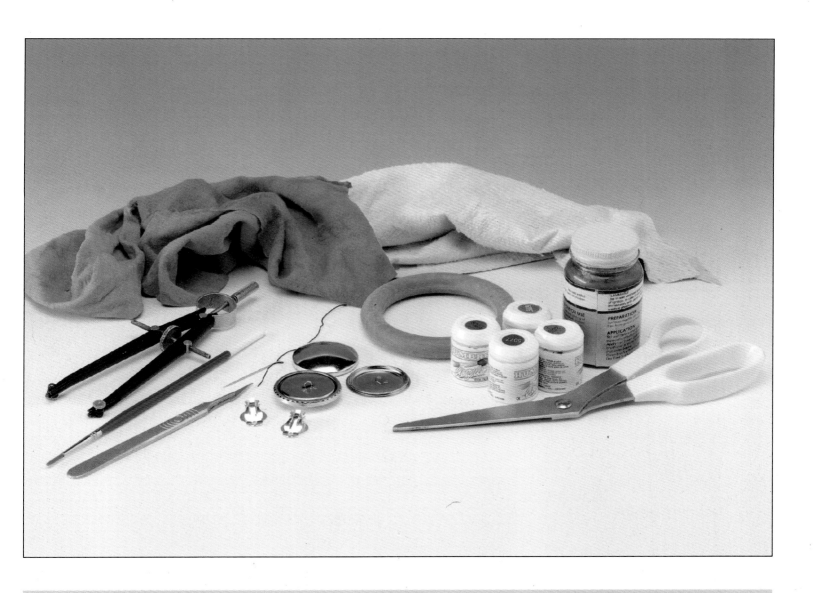

Materials

For this project you will require coloured suède, offcuts from leather manufacturers. Also, chamois leather from

car accessories shops, curtain rings and button moulds from soft furnishings and dress-making suppliers. You will need

acrylic paint, gold enamel paint and ear clips from hobby shops. You will also require scissors, a compass, paintbrush,

scalpel, needle and thread.

CHAMOIS BANGLE

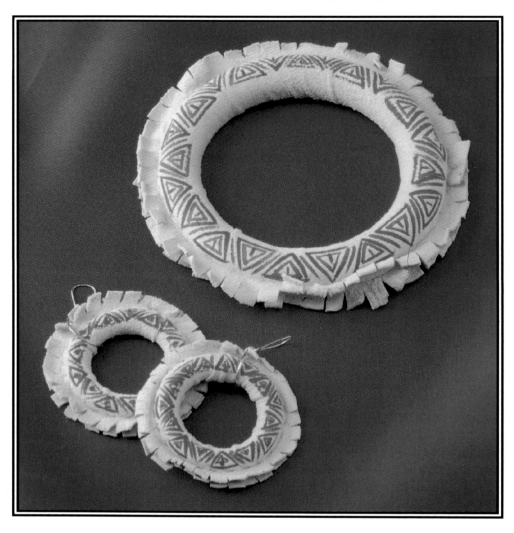

2 Wrap the strip of suède to cover curtain ring and tightly stitch the two edges together along the outer circumference of the curtain ring using thread the same colour as the chamois. Trim the chamois to leave a rim wide enough to fringe.

1 Mark out a strip of chamois leather to cover a curtain ring, leaving a 2.5cm (1") overlap. This can also be made with coloured suède, if preferred.

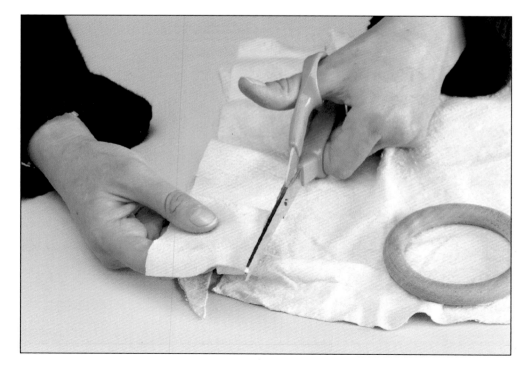

CHAMOIS BANGLE

3 With a fine brush, paint patterns on the chamois with matt acrylic paint.

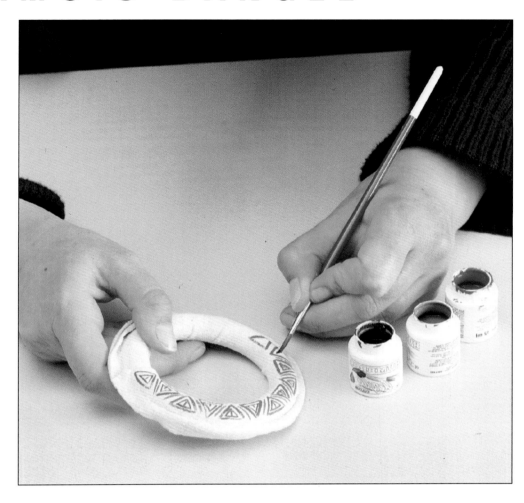

4 Snip the rim with sharp scissors to create a fringe.

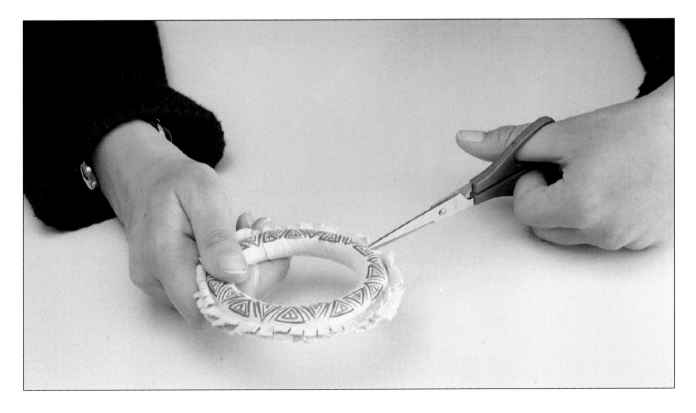

SUÈDE EARRINGS

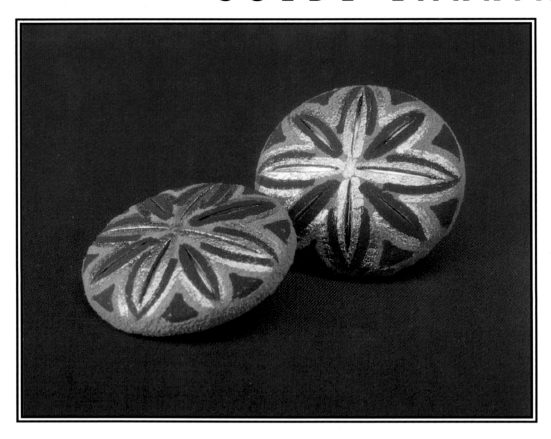

2 Using a compass, mark out the size of the button on the underside of the suède. Then mark another line 1cm ($^3/_8$″) larger than the diameter of the button.

1 Use two large metal button moulds. Remove backs, then with a pair of pliers pull out wires from button.

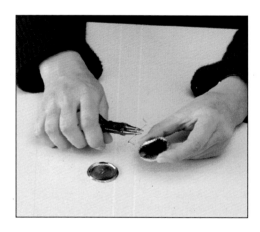

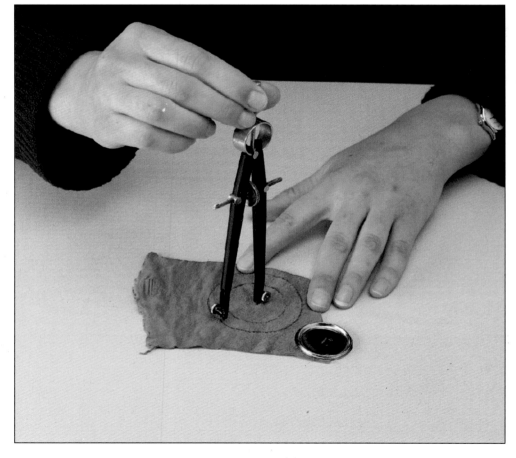

3 *Using a running stitch, stitch between the two lines. Draw in thread around button. Snap the back into place.*

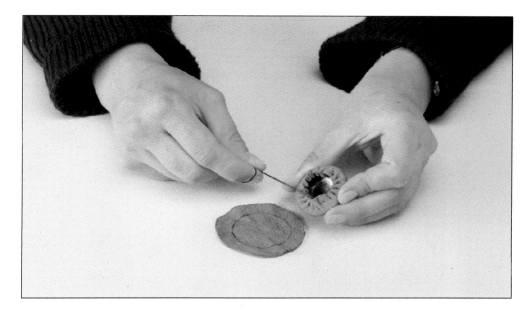

4 *With a pencil, mark lines on suède and carefully cut along these lines with a scalpel.*

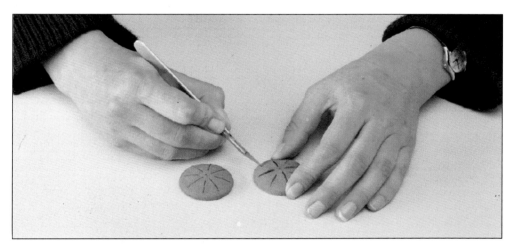

5 *With a fine brush, paint along the lines with acrylic and finish off with gold paint. Glue on ear-clips with strong adhesive.*

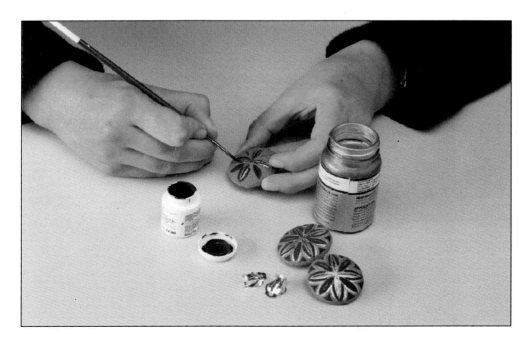

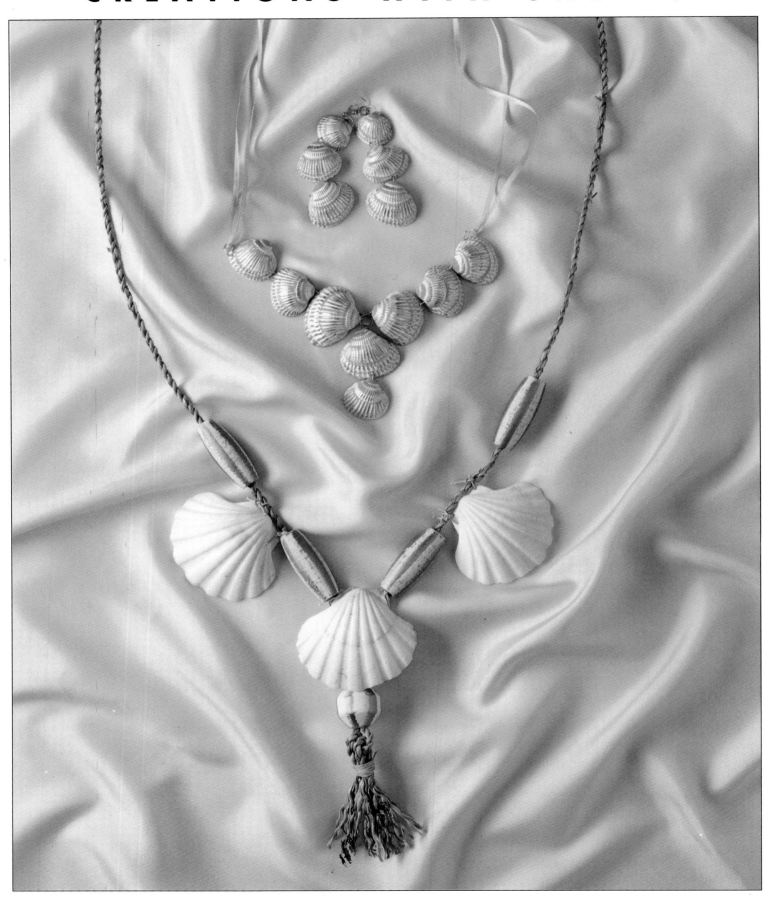

CREATIONS WITH SHELLS

LEFT

For a summer look, create these necklaces and earrings from sea shells. Pick up your own shells along the beach. If you live inland, these are readily available from craft and hobby shops.

The pink necklace is made up from painted shells threaded onto ribbon. The large necklace consists of shells drilled and attached to sea grass with painted wooden beads and a sea grass tassel.

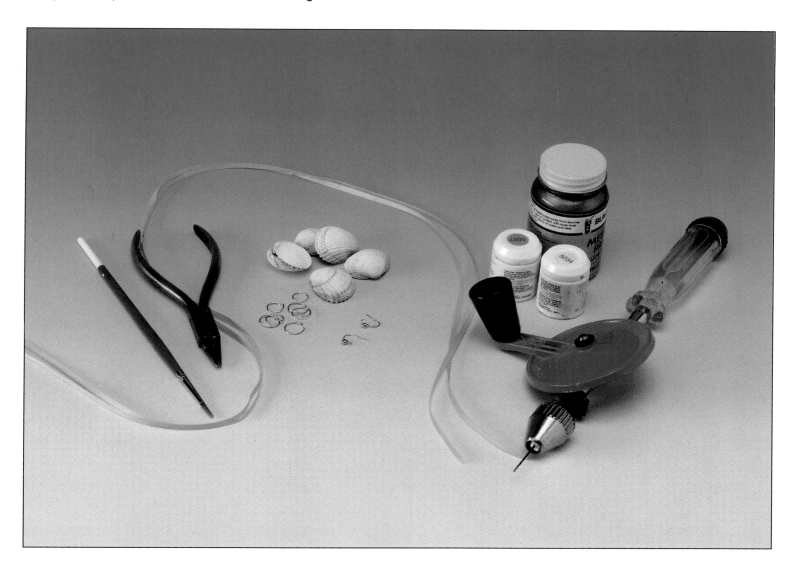

Materials

For this project you will need shells from the beach or gift shop, ribbon, white and pink matt acrylic paint and gold enamel paint from hobby shops. You will also need jump rings and ear wires and a fine paintbrush from craft shops. You will also require a pair of pliers and a fine drill.

SHELL EARRINGS

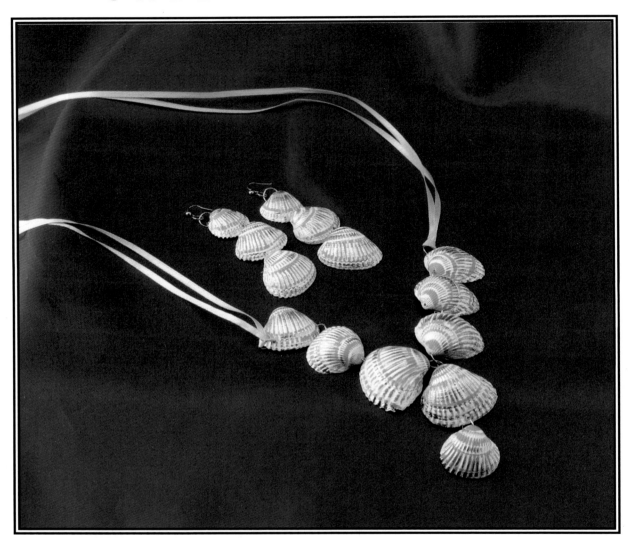

1 To make the earrings you will need six shells. Using a very fine drill, make holes at centre top and bottom of each shell. Take special care as they may splinter. It is a good idea to attach the shell to a block of wood, using some putty for extra stability.

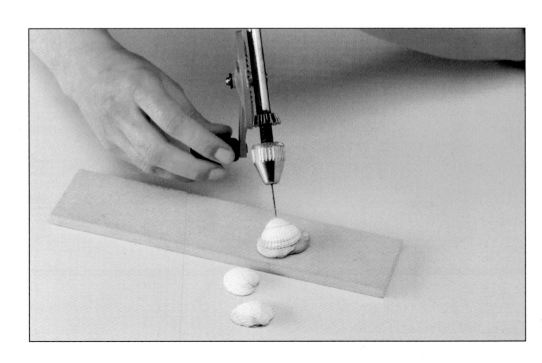

SHELL EARRINGS

2 Paint each shell with matt white acrylic paint and leave until dry. Then, with a fine paintbrush, pick out the fine detail of the shell with matt pink acrylic paint and leave until dry.

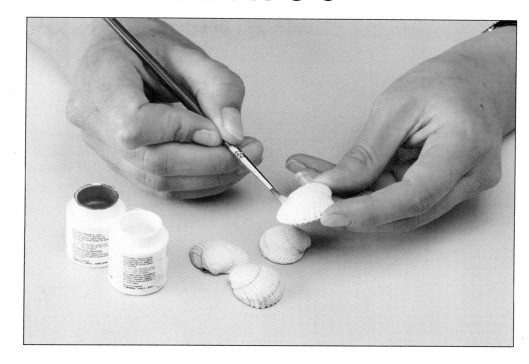

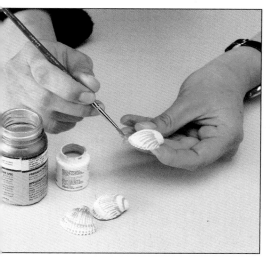

3 Finish off the effect by highlighting with gold paint.

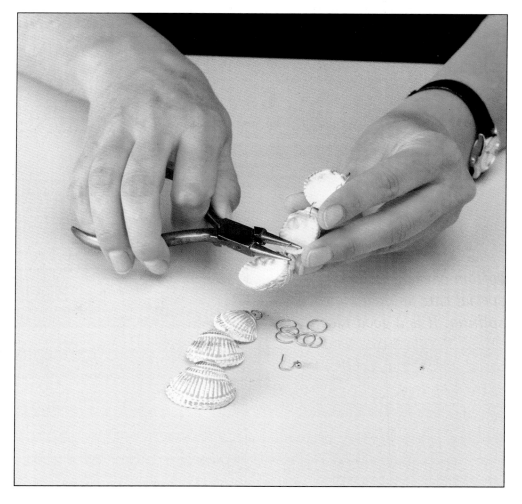

4 Join shells together using the pliers and large jump rings. Attach ear wires.

ADORNMENT IN PLASTIC

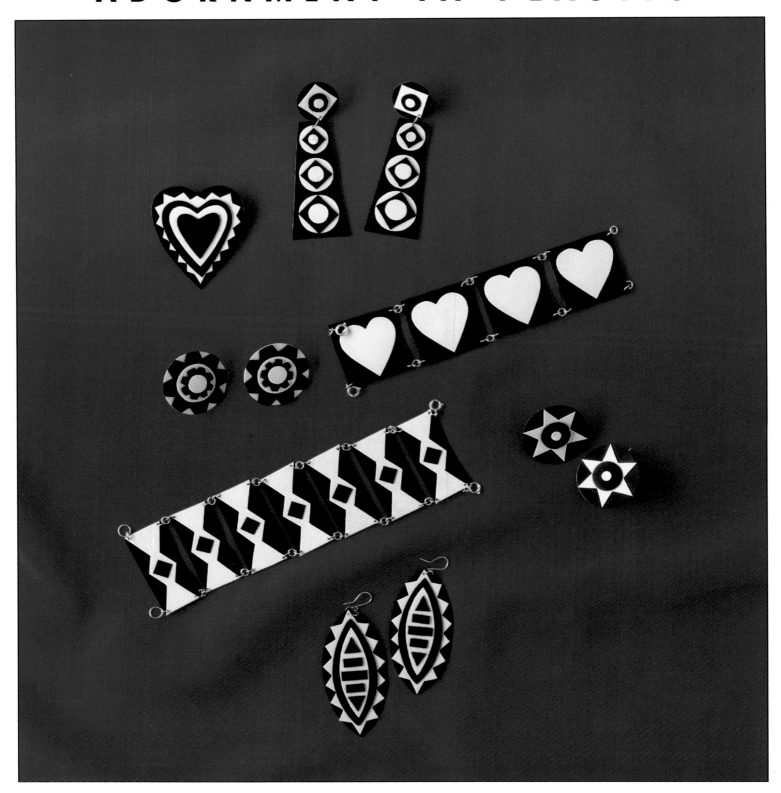

ABOVE

The above picture illustrates a selection of earrings, bracelets and brooches made from plastic sheet. This is a very light, flexible material and can easily be cut using scissors. Alternate layers of black and white shapes are built up in sharp contrast to produce an eye-catching effect.

ADORNMENT IN PLASTIC

Materials

For this project you will require plastic sheet (0.020" gauge), strong clear adhesive, impact adhesive, jump rings (links), bolt rings and flat back ear posts. You will also require round-nosed pliers, a very fine drill and a pair of scissors.

PLASTIC SHEET BRACELET

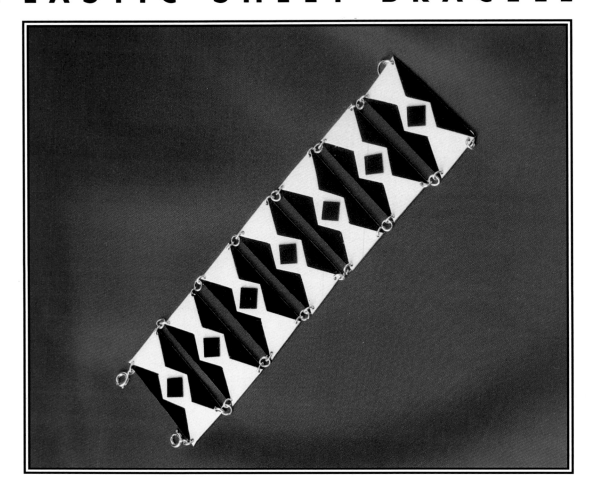

1 *Take one sheet of black plastic and one sheet of white plastic. Using template at the back of book, mark and cut out the required amount of shapes, remembering to adjust accordingly, depending on the size of your wrist.*

PLASTIC SHEET BRACELET

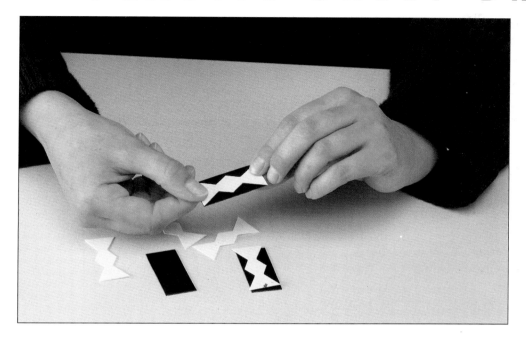

2 *Using a strong clear adhesive, glue each on, layer by layer. Let adhesive dry between each stage.*

3 *Secure section to a piece of wood, using tape, and drill small holes in each corner. Repeat until there are four holes in each section.*

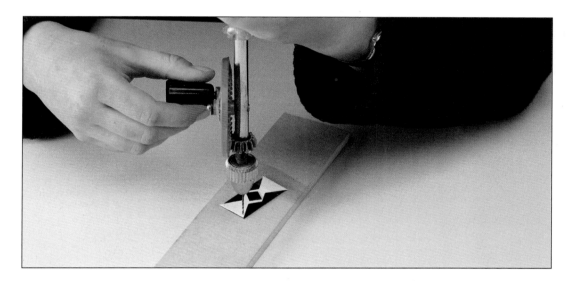

4 *Use three small jump rings to attach each section to the next hole. To open jump rings, twist sideways at opening and, using the round-nosed pliers, twist from side to side until joint fits tightly. Attach two bolt rings at each end to fasten.*

PLASTIC SHEET EARRINGS

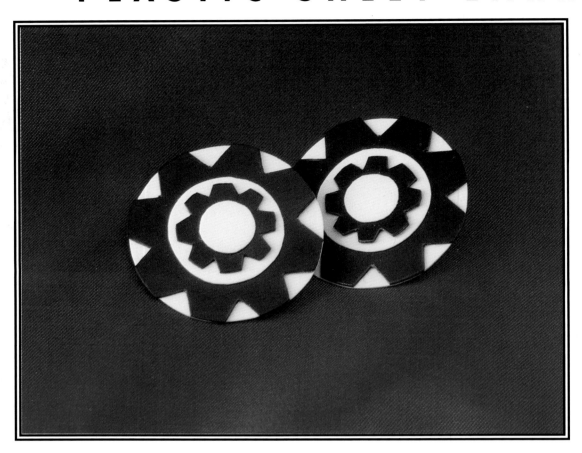

1 *Take one sheet of black and one sheet of white plastic. Mark and cut out shapes using the templates at the back of the book.*

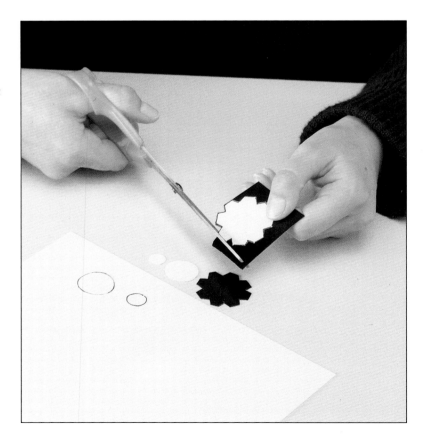

PLASTIC SHEET EARRINGS

2 Using a strong, clear adhesive, glue each on layer by layer. Let adhesive dry between each stage.

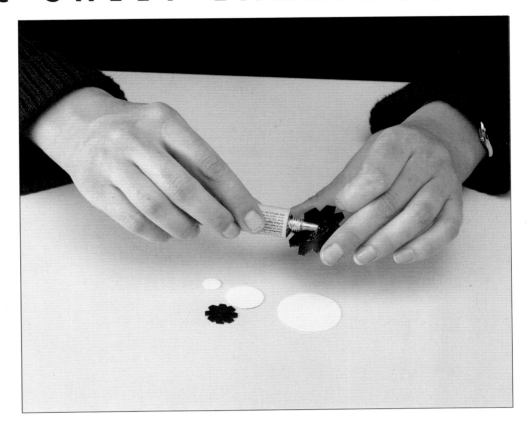

3 Glue on flat pad ear posts with a strong impact glue.

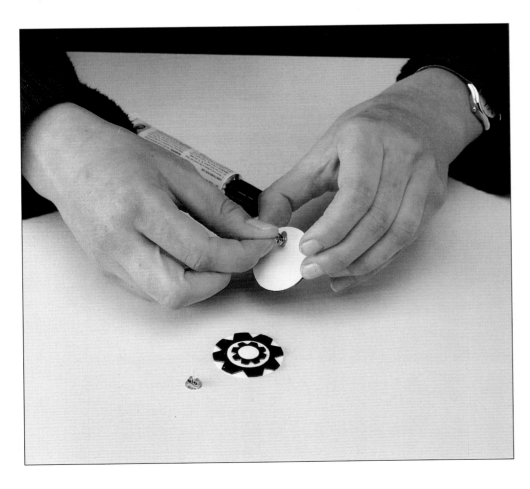

TASSEL MAGIC

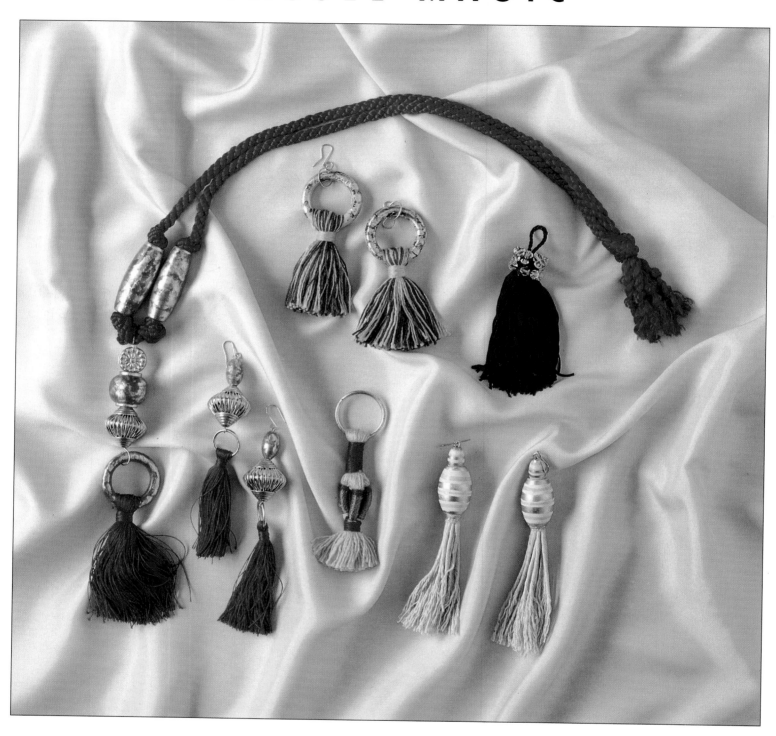

ABOVE

Tassels can be made using a variety of cords and threads. Seen here are examples made from mercerized cotton, embroidery threads, parcel string and silk attached to painted wood, brass curtain rings and beads. Tassels may be bound at different intervals to create an ethnic appearance. A dress-making or upholstery suppliers is a good source of ready-made tassels, cords and curtain rings. Glass beads can be sewn onto the tassels to produce a sparkly effect. The necklace illustrated is made from silken cord, painted wooden beads, brass beads and a silk tassel.

TASSEL MAGIC

Materials

For this project you will need brass curtain rings, silk thread, a sewing needle and wooden beads, brass beads and earring wires.

You will also need gold-plated wire, matt white, glossy red and gold enamel paint, from craft/hobby shops. You will also require

round-nosed pliers, a pair of tin snips and a pair of scissors.

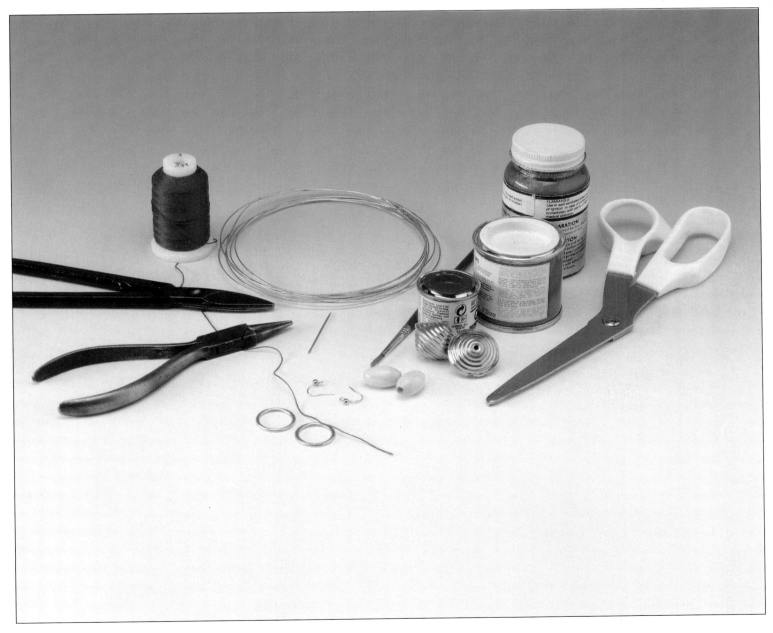

TASSEL EARRINGS

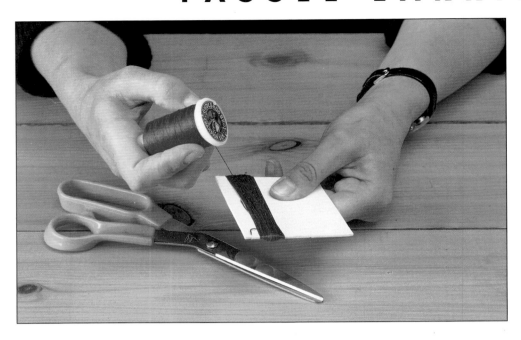

1 LEFT: Cut a piece of card as long as required for the tassel and wind the silk thread around. Cut through the threads along one edge of the card and carefully place through the gold-coloured hoop. Double thread a needle, the two ends passing through the eye. Take the loop around the head of tassel. Thread the needle through it and pull tight. Wind around the head several times passing the thread up through the top of the tassel and snip.Tidy up the edge of the tassel by trimming it.

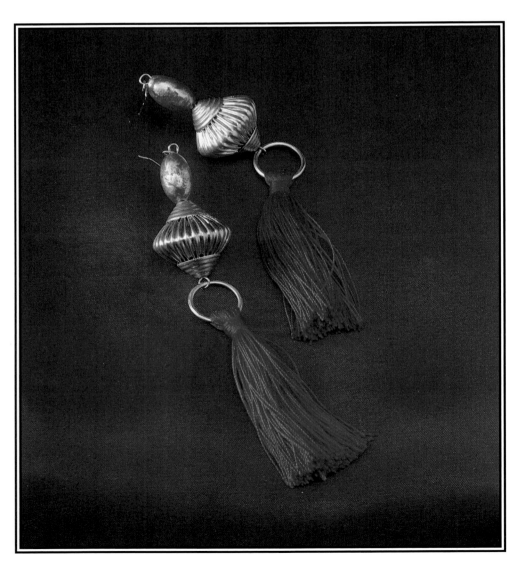

2 TOP RIGHT: Take two small wooden beads, paint with matt white enamel and allow to dry. Then paint with red enamel and allow to dry. Using a small brush, dab on the gold paint to produce a mottled effect.

3 Take a length of gold-plated or brass wire and make a small loop using the round-nosed pliers. Attach tassel loop to this. Thread on a large brass bead, then a wooden bead. Cut off excess wire. Make a small loop at the end and fasten earring wire.

TASSEL EARRINGS

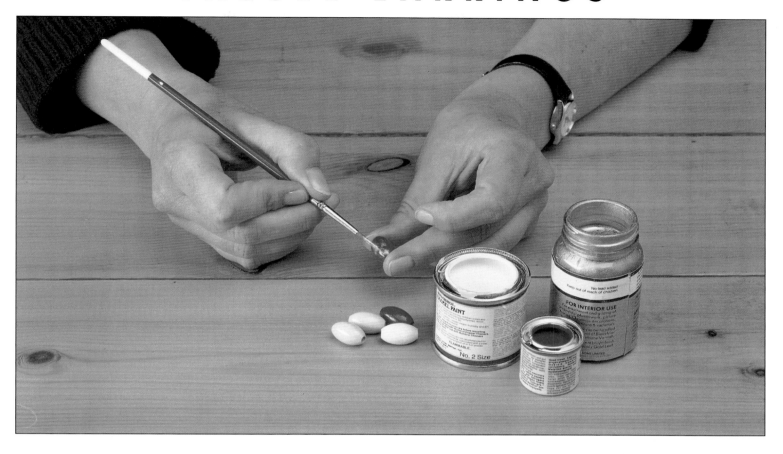

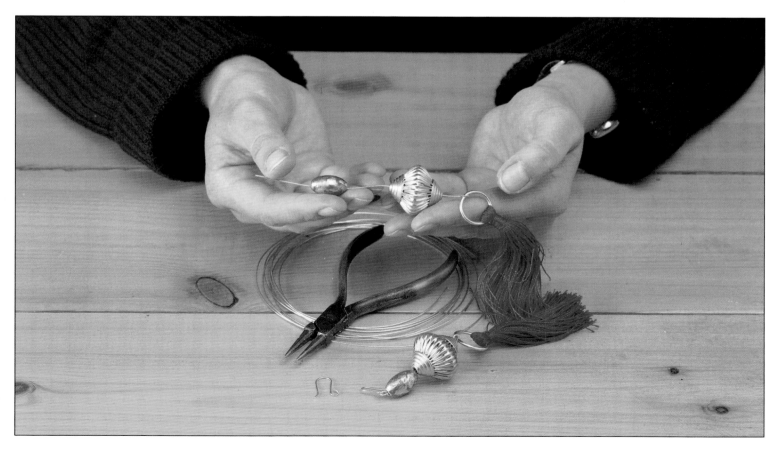

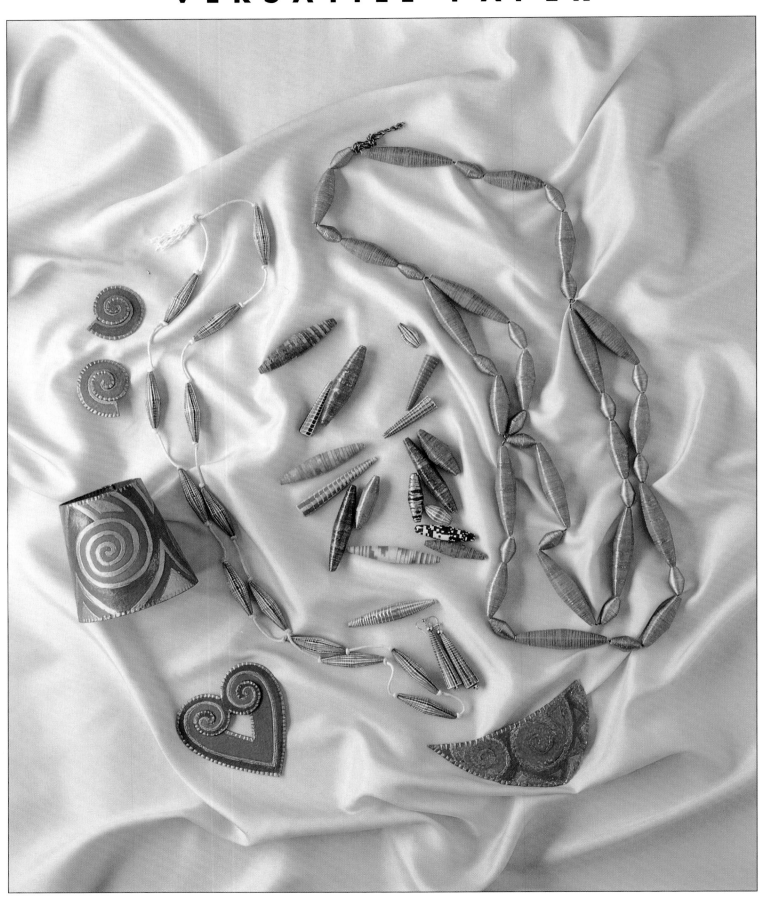

VERSATILE PAPER

LEFT

This photograph demonstrates the versatility of paper, an inexpensive and easily accessible material. Treated in certain ways, attractive jewellery can be easily fabricated. Using simple paint techniques, the pieces become strong and hard-wearing, quite different from their original form. Here are examples, using thick textured watercolour paper which has been decorated with a mixture of polyvinyl acetate (P.V.A.) and paint. This results in a very tough surface. Also on display, are beads made from tightly rolled cartridge paper strung onto metallic cord and string.

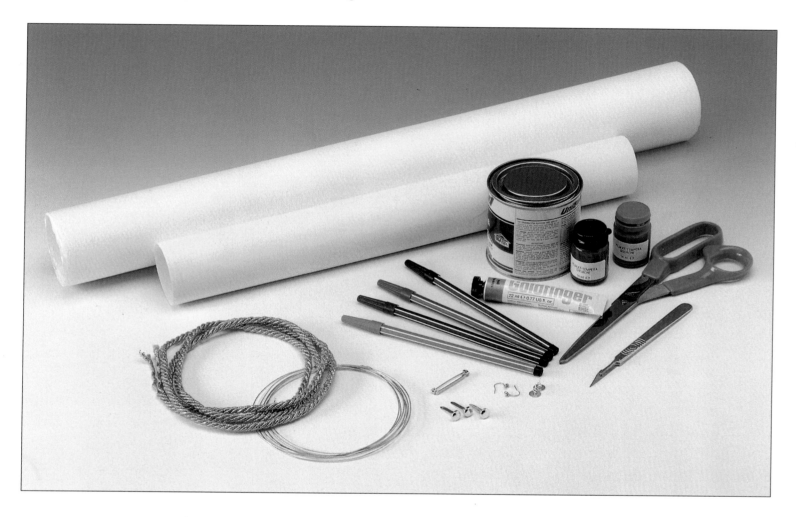

Materials

For this project you will need watercolour paper (rough cold press 300 lbs), cartridge paper, poster paints, felt-tipped pens, tube of gold wax and gold enamel paint, from art shops. You will also need gold cord, impact adhesive, scalpel/ craft knife, tin snips, gold-plated wire and a round-nosed pliers, sponge, brooch back, earring wires, flat back ear posts, beads and paper fasteners. All from craft/hobby shops.

PAPER BEAD NECKLACE

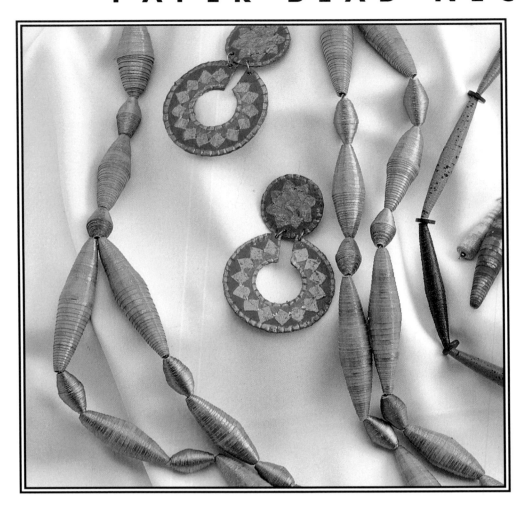

2 Using a sponge, cover the paper with a thin layer of P.V.A. Leave to dry until clear.

3 Using a soft cloth, rub on gold wax sparingly. Leave wax to dry.

1 Take three sheets of cartridge paper, one for small beads, one for gold beads, and one for large beads. Sponge green, turquoise and a small amount of white poster paint onto two sheets of paper to create a streaky effect on two of the sheets. Paint gold paint onto the third sheet.

PAPER BEAD NECKLACE

4 On reverse of paper, mark out triangles. For large beads, mark out triangles with a base of 10cm (4"). For medium beads, mark out triangles with a base of 5cm (2"). For small beads, mark out triangles with a base of 3cm (1¼").

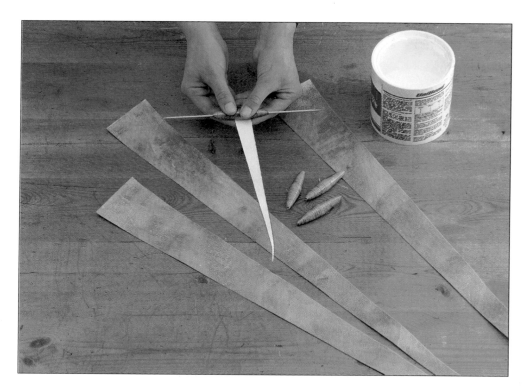

5 To make bead, wrap triangles around a knitting needle. Make sure that the triangle is held tightly and that the pointed end stays in the middle. Glue point down firmly.

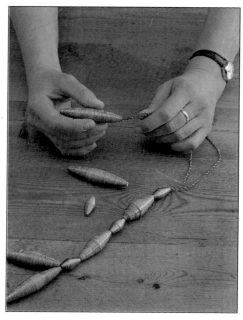

6 Thread beads onto cord. Start threading two lengths of cord for the double part of the necklace, one with two less beads than the other. This makes up the front part. Then joining the two threads together, continue threading evenly on each side to make a single strand for the back. Finally knot all four cords together.

PAPER EARRINGS

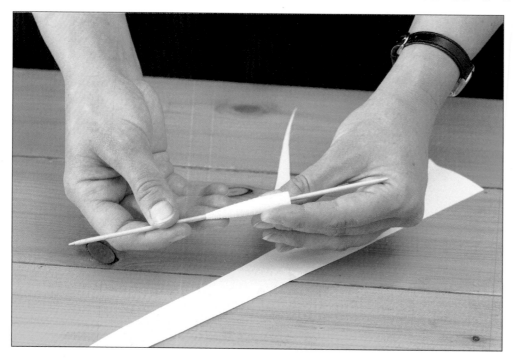

1 Left: Cut two triangles with a base of 5cm (2") out of cartridge paper. (see previous project). Again, roll tightly around the knitting needle but roll this off centre so that the tag finishes at one end. This should leave you with a cone shaped bead. Glue the end firmly.

2 Top Right: Using coloured felt-tipped pens, draw alternate lines using four different colours. We have used browns.

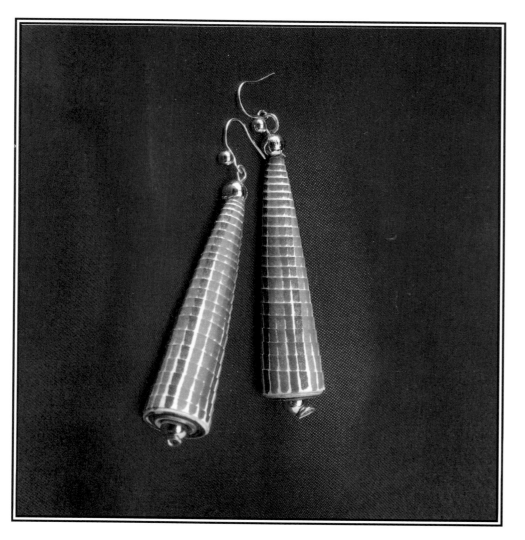

3 Right: Cut a length of gold-plated or brass wire. Make a loop at one end and thread on one small bead slightly larger than the hole, then add the paper bead and then another gold one. Cut off the excess wire, make another loop and fix on the ear wires.

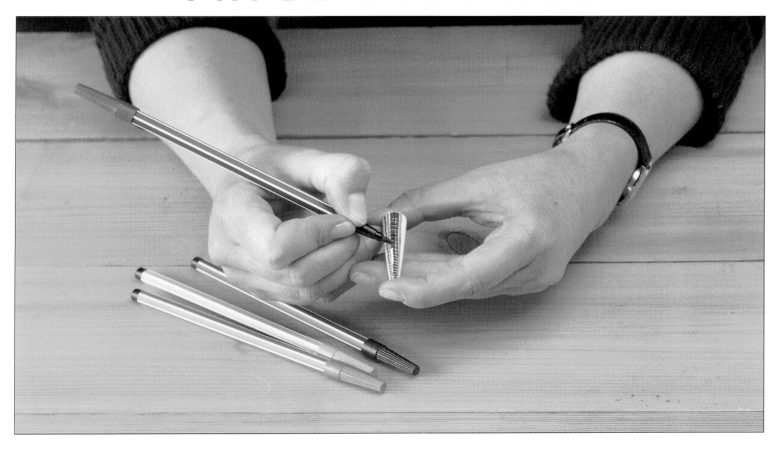

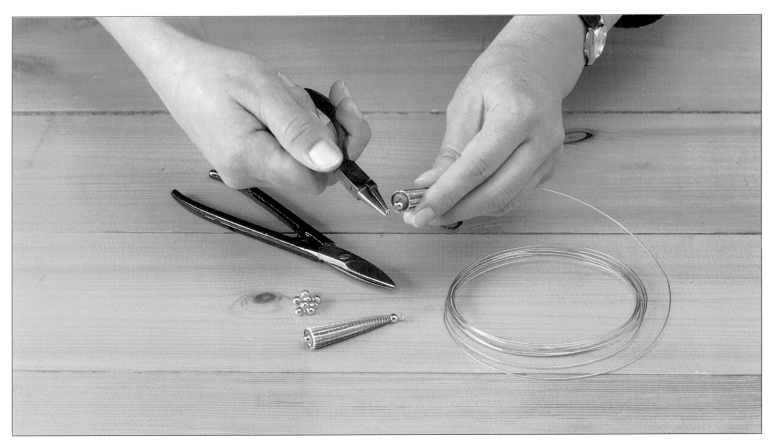

PAPER CUFF

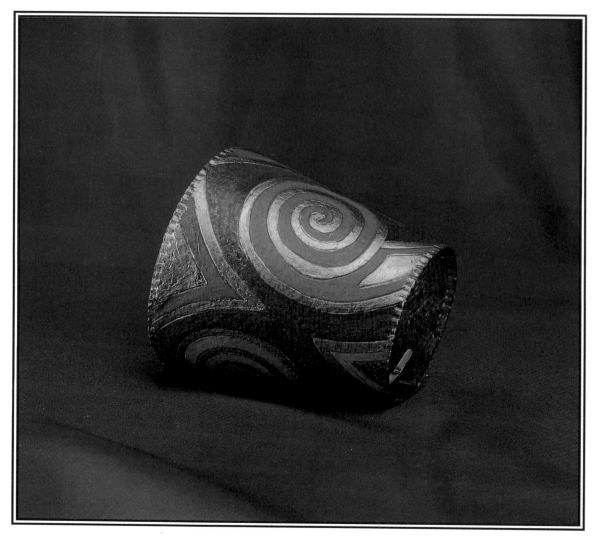

1 Mark out cuff shape on cold press 300lb watercolour paper. *If not available, any water-colour paper of the thickest possible weight will do. Use template at back of book.*

2 Using a pencil, mark a pattern of your choice, or use template.

PAPER CUFF

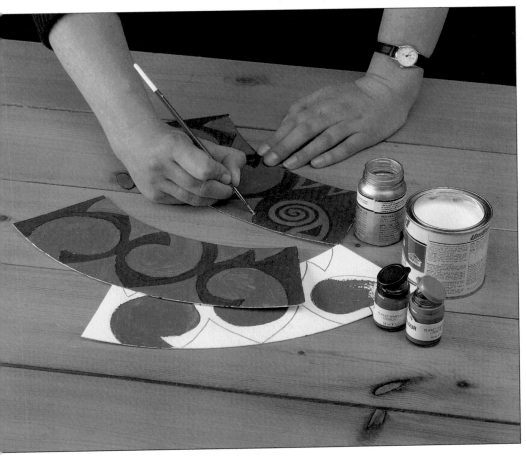

3 Mix turquoise paint with P.V.A. Add a little water if mixture is too thick. Paint on patterns and leave to dry. Mix brown poster paint with P.V.A. and paint in patterns, leave to dry, then paint the reverse side.

Paint lines around the patterns using the gold paint. When it is dry, emboss a fine line on either side of the gold using a blunt knitting needle.

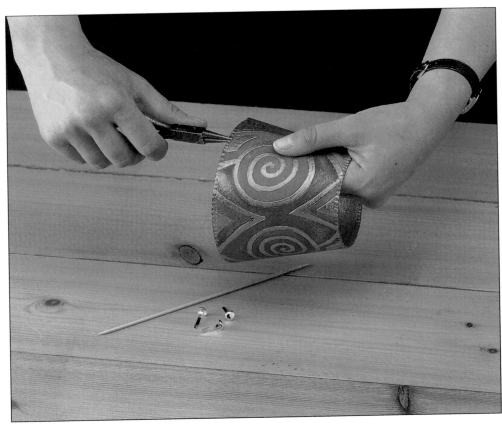

4 Gently form into shape, overlap edges of the cuff and make three holes through both edges. Push through gold-coloured paper fasteners. Finish off by crinkling edges with round-nosed pliers.

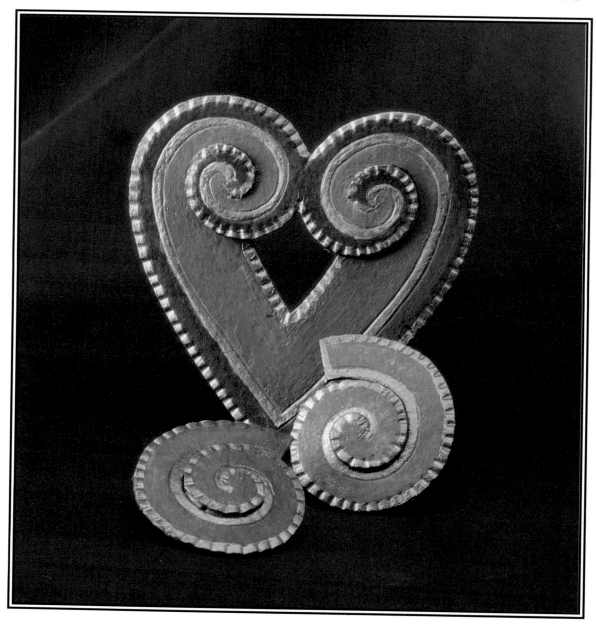

1 *Mark out shapes using templates at the back of book. Cut outline using scissors. Cut out inner lines with a scalpel to create the spirals.*

PAPER BROOCH & EARRINGS

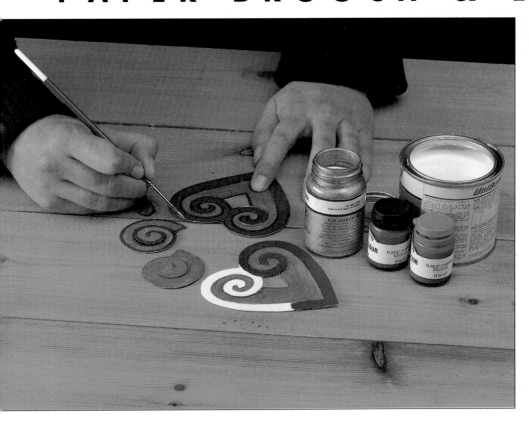

2 Mix turquoise poster paint with P.V.A. and fill in the patterns. If mixture is too thick, add a little water. Leave to dry. Mix brown poster paint with P.V.A. and fill patterns, leave to dry. Then paint back of brooch and earrings with this mixture. With gold paint, paint the edges of the earrings and brooch and also between the turquoise and brown pattern of the brooch. When dry, emboss a line along the edges of the gold paint using a blunt knitting needle.

3 Crinkle edges, using round-nosed pliers. Glue flat pad ear posts on the back of the earring. Glue brooch onto brooch back using a strong, clear adhesive.

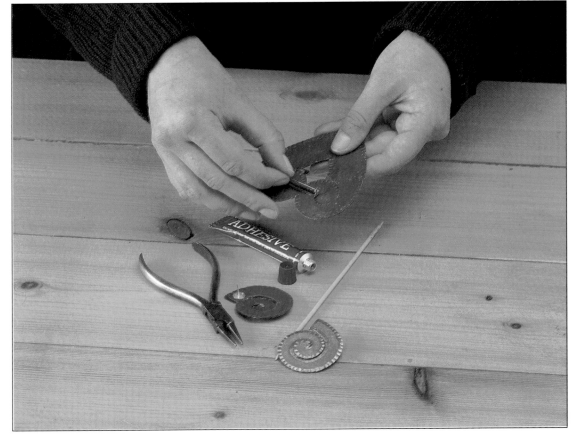

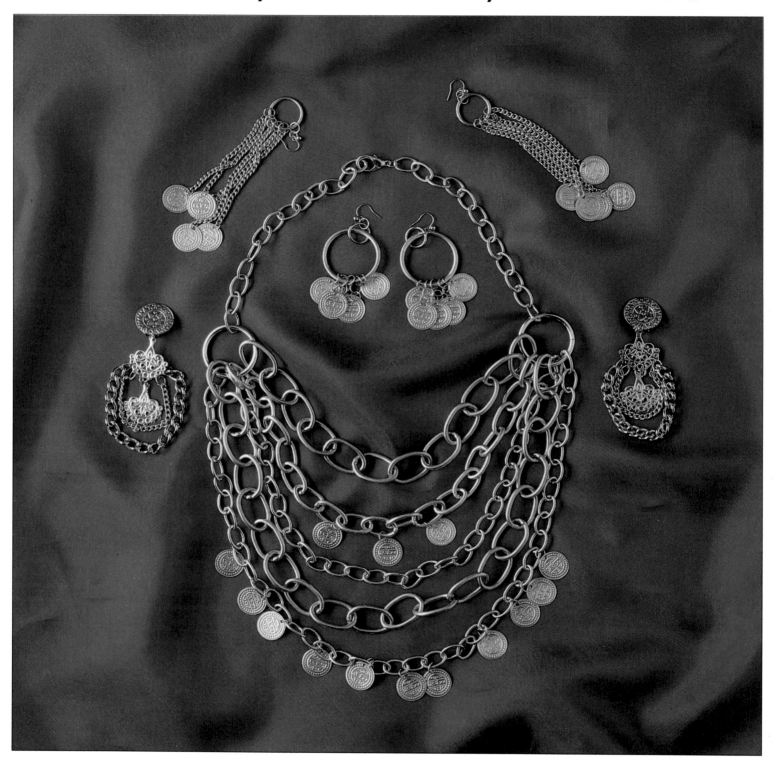

ABOVE

Illustrated here are a variety of earrings and a necklace made from chain readily available from most good DIY stores. Although a commonly used material, chain can be used to good effect to produce some stunning pieces. The necklace is made from different thicknesses of gold-coloured chain. Stamped metal coins are added for decoration. The earrings are made from chain purchased from a craft shop and hung from brass loops, and fancy metal stampings decorated with metal coins.

CHAINS, CHAINS, CHAINS

Materials

For this project you will need brass-finish chain cut to length from DIY shops. You will need metal zip fastener hoops from dress-making suppliers. You will also need drilled coins, jump rings, clasp fastener, from craft/hobby shops, and a pair of round-nosed pliers.

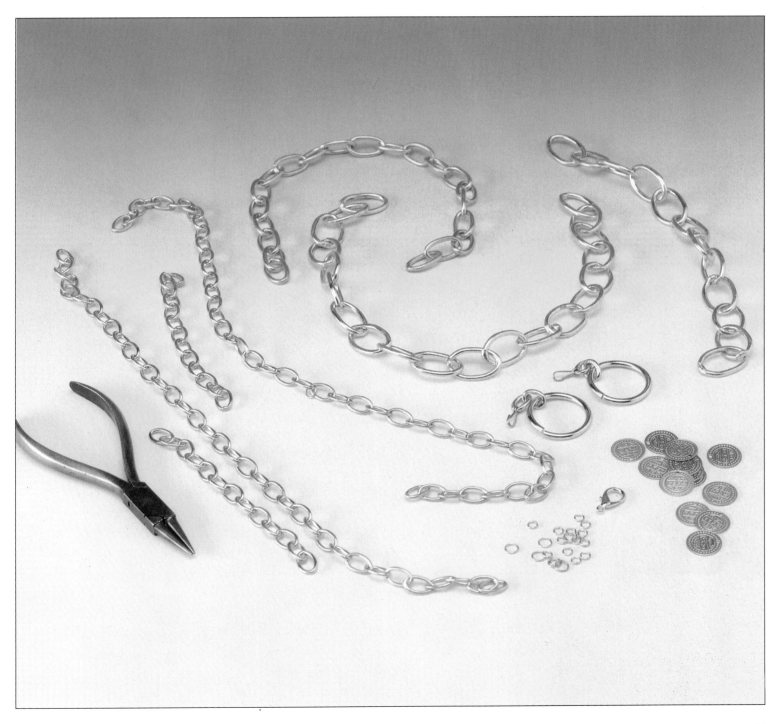

CHAIN NECKLACE

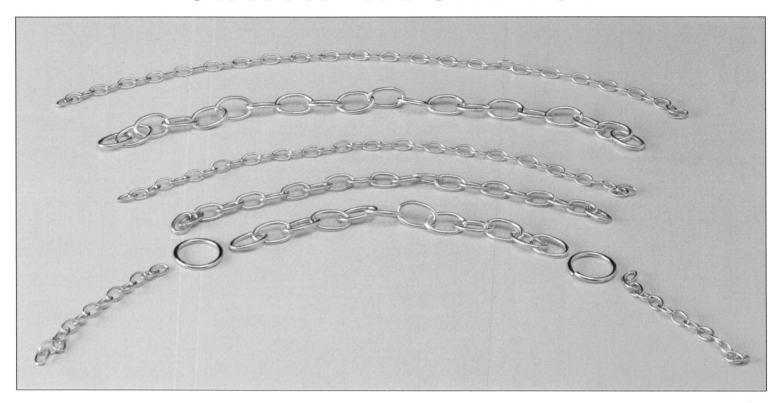

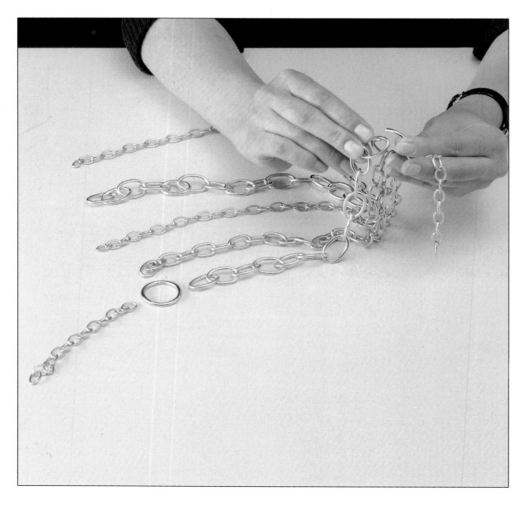

1 *Buy the chain and ensure that it is cut to length as it is difficult to cut by hand. Lay out as illustrated. Length of chains are:-*

Thin chain x 2 @ 14 cm (5$^{1}/_{2}$")

Thin chain @ 36cm (13$^{3}/_{4}$")

Thin chain @ 47cm (18$^{3}/_{8}$")

Thick chain @ 25cm (9$^{3}/_{4}$")

Thick chain @ 42cm (16$^{1}/_{2}$")

Medium chain @ 30cm (11$^{3}/_{4}$")

Two hoops from zip pulls are also required. Simply remove hook fasteners from zip pull so that just the hoop is left.

2 *Place the lengths of chain, in the order illustrated, onto the hoops. Join hoops by twisting from side to side.*

CHAIN NECKLACE

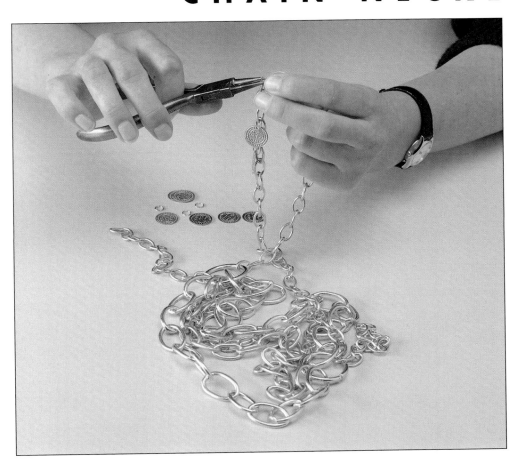

3 Using round-nosed pliers and jump rings, attach coins to chain.

4 Attach clasp fastener.

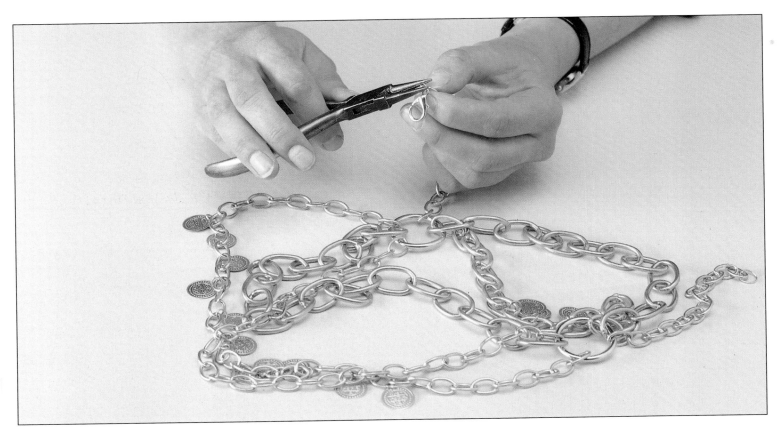

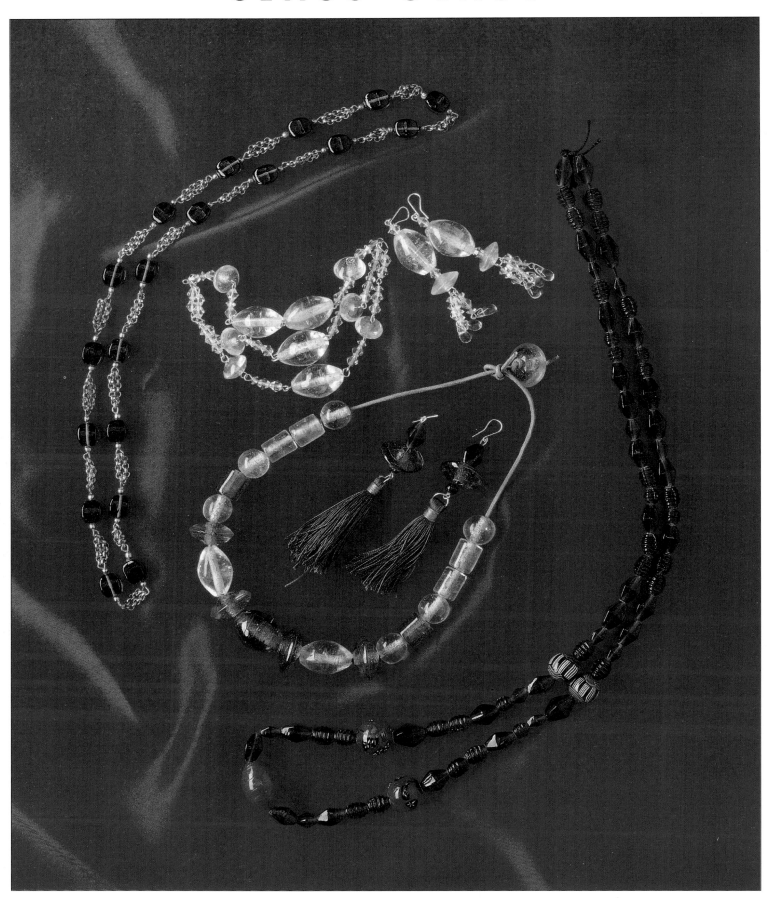

CLASS GLASS

LEFT

Glass beads from all over the world are widely available in many colours, shapes and sizes from mail-order catalogues, specialist bead shops or flea markets. Here are necklaces made from beads strung on to silk cord and leather thongs. Another example shows beads on looped wires joined together with doubled pieces of chain. Knots can be tied between each bead to form a different, contrasting texture. Silk tassels are added onto bead earrings. The transparent bracelet and earrings are made from large, smooth glass beads juxtaposed with small faceted beads threaded onto wires to allow the piece to be flexible.

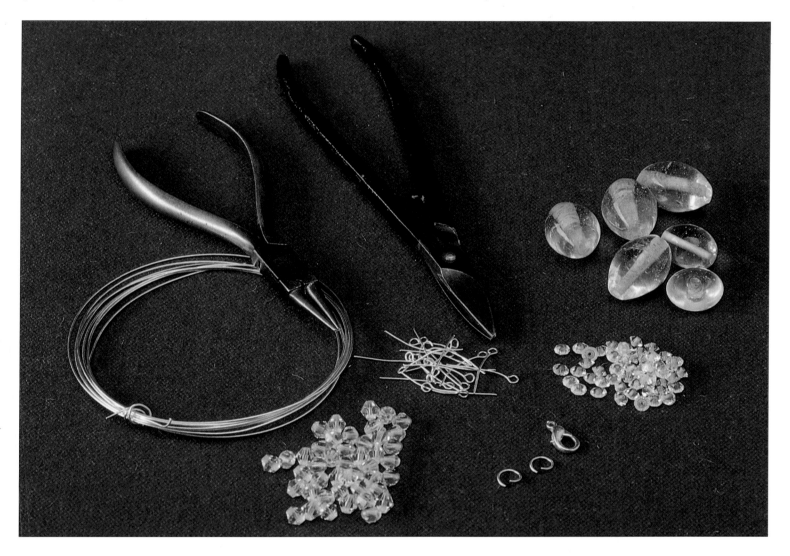

Materials

For this project you will need large glass beads, small faceted beads, silver-plated wire, silver-plated wires with loops, jump rings and bracelet clasp, from craft/hobby shops. You will also require a pair of round-nosed pliers and tin snips.

GLASS BEAD BRACELET

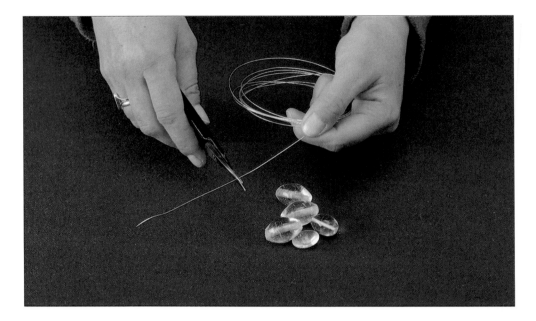

1 *Cut lengths of fine gauge silver-plated wire, long enough to go through the large glass beads. Add extra length in order to form loops at either end.*

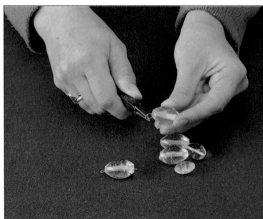

2 *Thread the wire through the bead, and using round-nosed pliers, bend loops on either end of wire. If the wire is too long, snip off the excess before bending the second loop.*

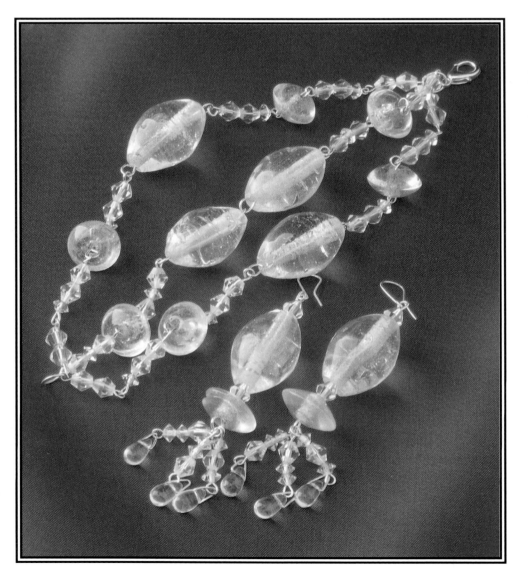

GLASS BEAD BRACELET

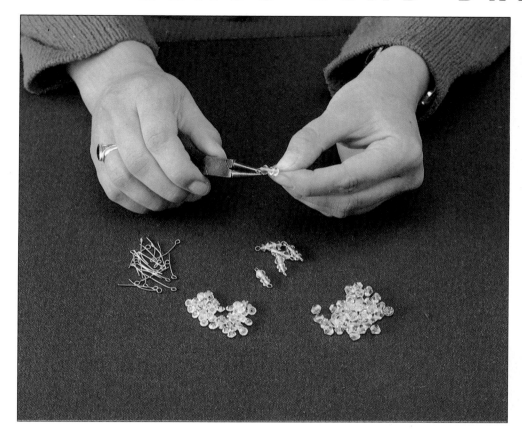

3 Thread three small beads on to the eyepins and make another loop at the other end using the pliers.

4 Join sections together by linking the end loops. The central string of beads is slightly larger than the outer two.

5 Join the three ends together using a strong jump ring. Repeat at the other end and fasten a clasp to the jump ring.

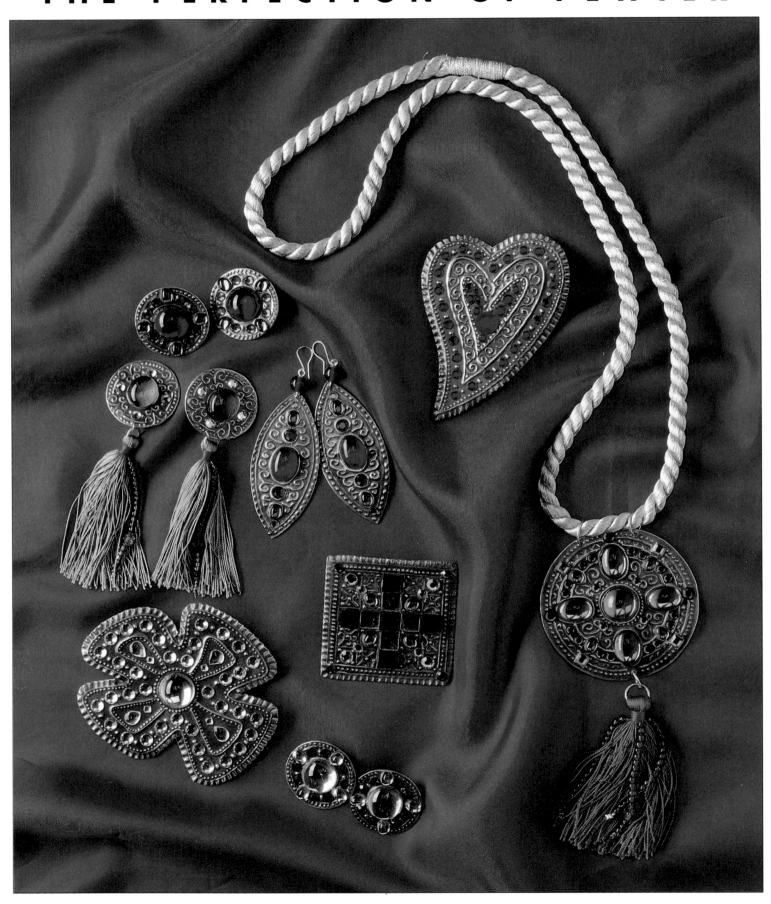

THE PERFECTION OF PEWTER

LEFT

This picture shows a selection of jewellery made from embossed pewter and decorated with glass stones and tassels which add a sparkle of colour. Pewter is a very soft, malleable metal. All this jewellery is made in relief from the wrong side using 0.007" gauge pewter which is mounted onto aluminium. It can be easily cut using tin snips or scissors. It is also easily bent, so care must be taken when cutting it. The pewter requires support while the patterns are being pressed in, so it is necessary to use a rubber mat. These pieces have all been treated with patina to produce an antiqued effect.

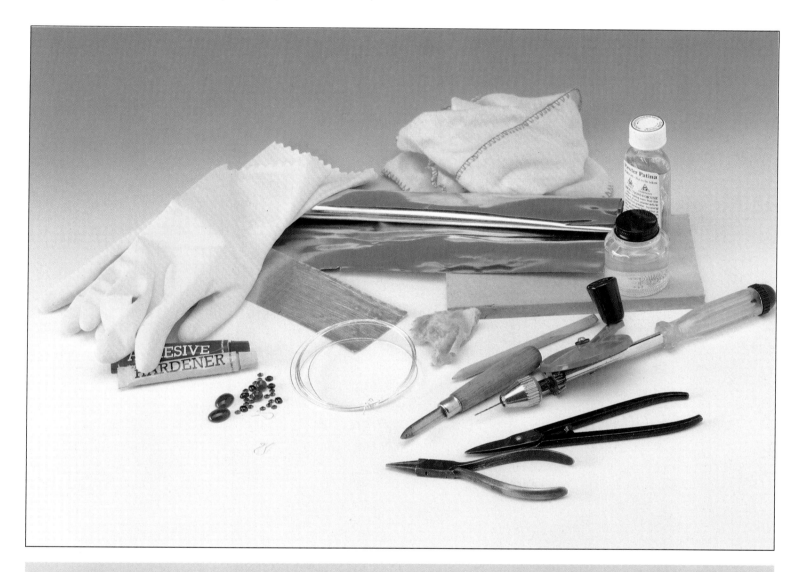

Materials

For this project you will need pewter (0.007" gauge), aluminium (0.70mm thick), pewter patina, silver-plated wire, wooden modelling tool, stones, ear wires, all from craft shops. You need metal polish, soft cloth, two-part epoxy resin, burnisher, tin snips and round-nosed pliers, all from DIY shops. You will need rubber gloves, acetone and a rubber mat.

PEWTER JEWEL EARRINGS

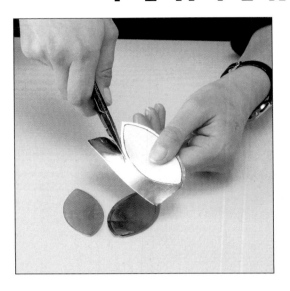

1 Cut out shape in aluminium (0.70mm gauge) using template in the back of the book. Mark aluminium template on pewter and cut out pewter with an overlap edge of approx. 4mm. Snip a small 'V' at the top and bottom of the pewter to allow it to fit snugly around the aluminium template at a later stage.

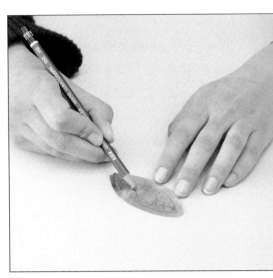

2 Using a pencil, mark out on the pewter where the stones are to be placed, drawing around them. Then draw patterns around the stone areas taking care not to draw on the overlapping edge.

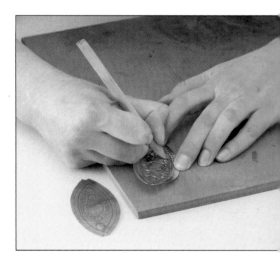

3 Place the pewter on the rubber mat and gently press over the pencil lines using a wooden modelling tool. The pewter is then worked from the wrong side.

4 *With the right side uppermost, fold the pewter overlap around the aluminium shape.*

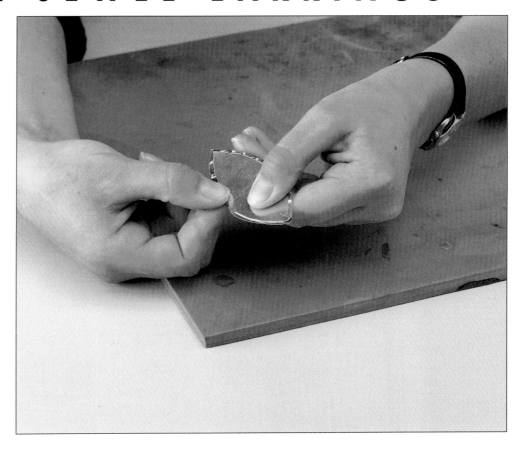

5 *Using a burnish or the back of a spoon, press the edge of the pewter down firmly and rub until smooth.*

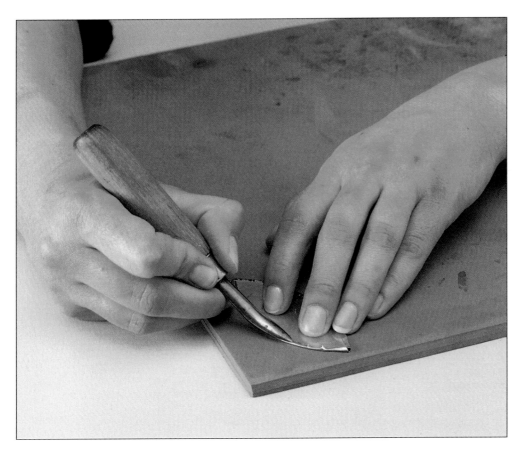

6 Moisten a soft cloth with acetone and rub surface to remove all traces of grease.

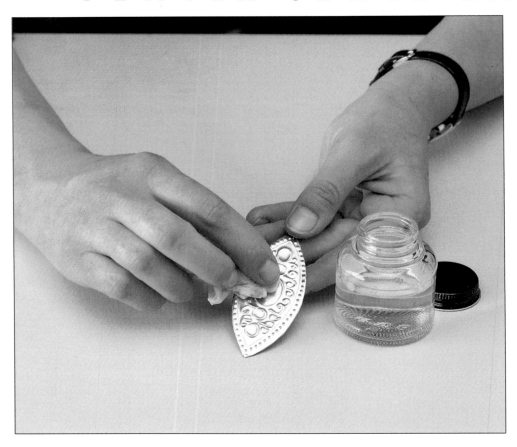

7 Wear rubber gloves to protect your skin and dampen a soft cloth with pewter patina and gently rub on the pewter. Leave for ten minutes until the pewter is black. Using a soft cloth, buff up the pewter with metal polish until a shiny finish is obtained. Repeat step six to de-grease.

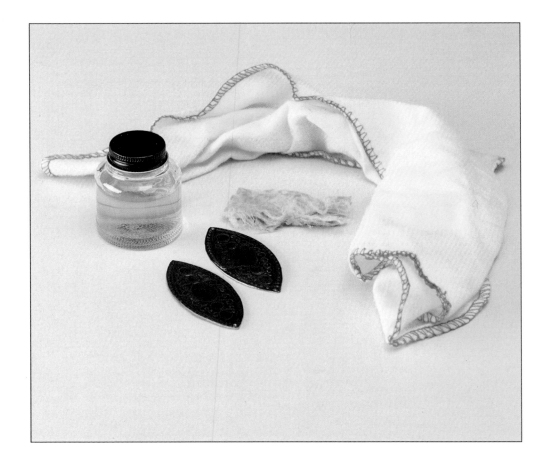

PEWTER JEWEL EARRINGS

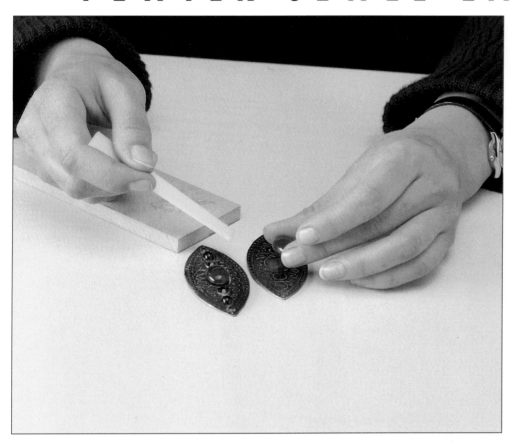

8 Using a two-part epoxy adhesive, glue stones in place. Leave to dry, following the manufacturer's instructions.

9 With a fine drill, drill holes in the top of the earring. Attach looped wire with beads (see also page 61 et seq. for method). Attach ear wires.

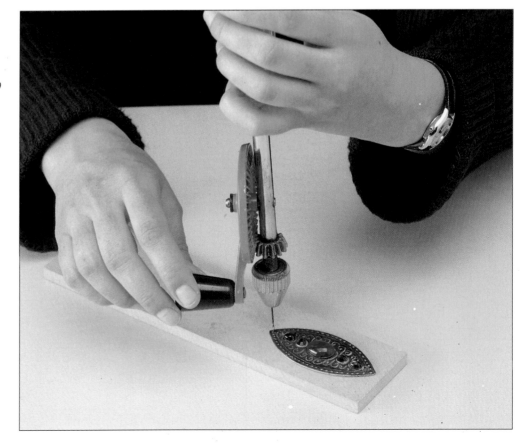

Warning
Dangerous chemicals are used in this chapter. Always follow the manufacturer's instructions on the labels. Take care to protect work surfaces.

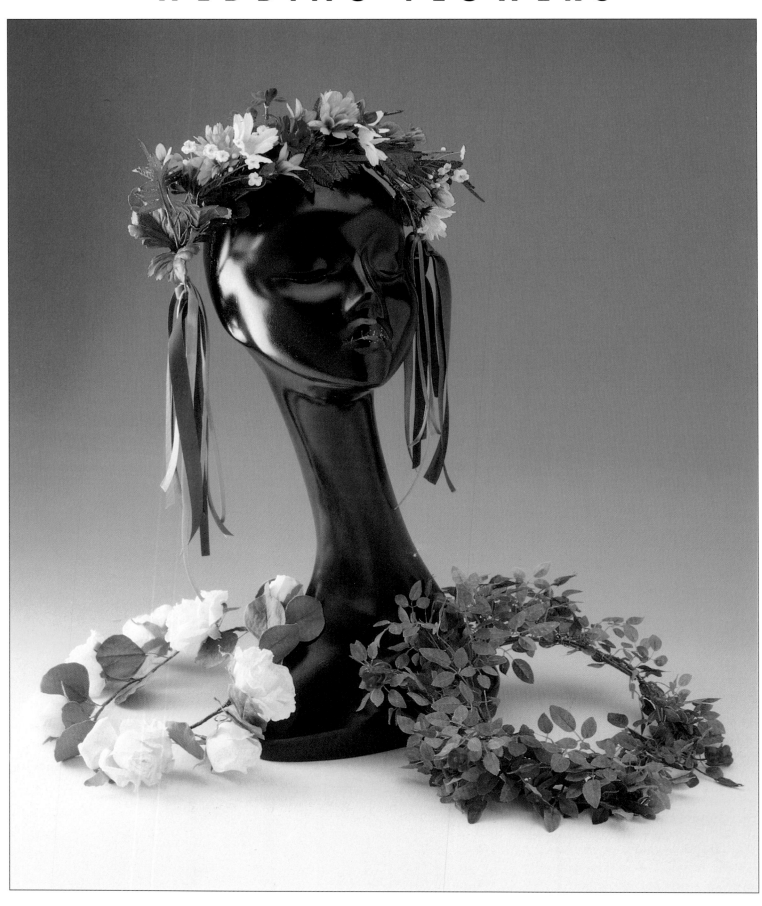

WEDDING FLOWERS

This picture shows three different types of headdresses made from silk flowers and foliage. White roses and leaves are used to good effect in one of the headdresses. Another consists of a large bunch of various flowers cut up into clumps and taped to wire which makes the headdress look very 'full'. Loops are placed at either end for attachment. The finishing touch is added by hanging ribbons from these end loops. The third headdress is made by putting wild roses and leaves together, creating an extremely natural effect.

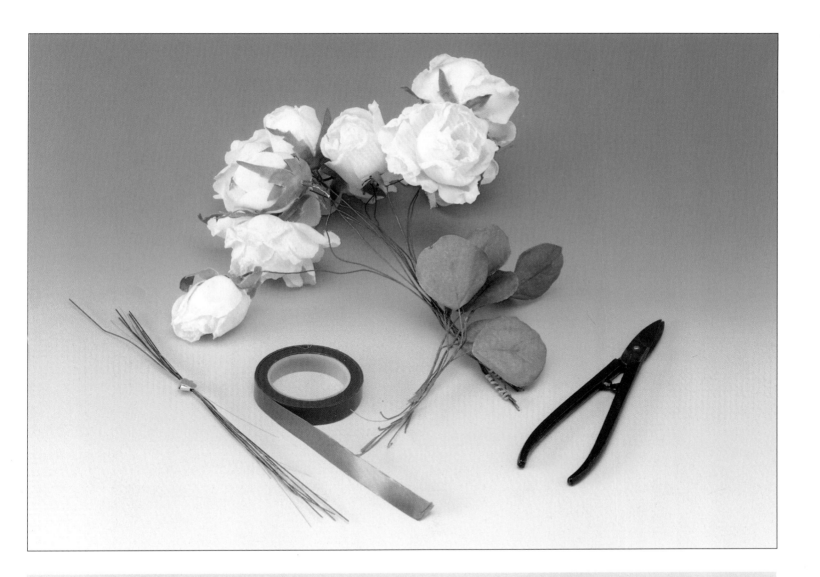

Materials

Everything you require is available from most good florists' shops. You require a selection of silk flowers and leaves,

a pack of florist's wire and a roll of florist's tape.

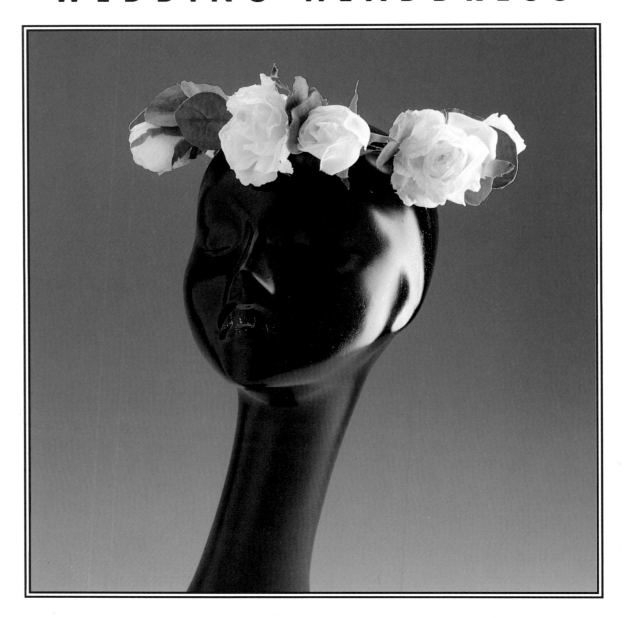

1 Tape together three pieces of florist's wire to form one long piece. Measure it to fit head – the average size head is 52cm (20³⁄₈"). Bend to form circle of appropriate length and tape the overlapping ends together. The florist's tape is gently pulled to stretch while twisting around the wire. This allows it to adhere.

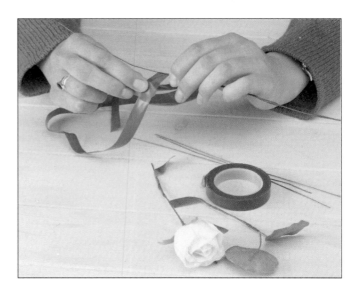

WEDDING HEADDRESS

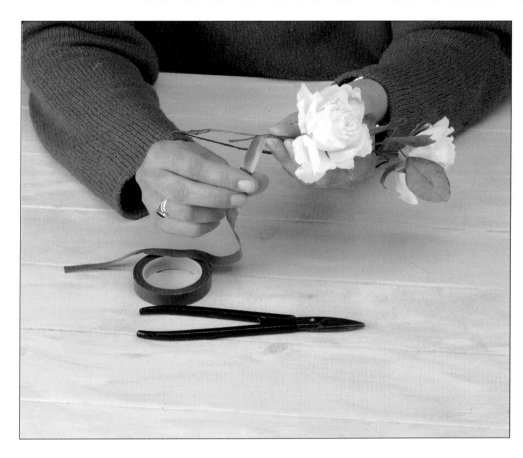

2 Cut the flowers and foliage to length, approx. 8cm(3¼"). Tape each piece in place.

3 Lay out the flowers and foliage in position ready to tape them to the wire circle. Tape flower and foliage alternately all around the circle until complete. Be careful to space them evenly.

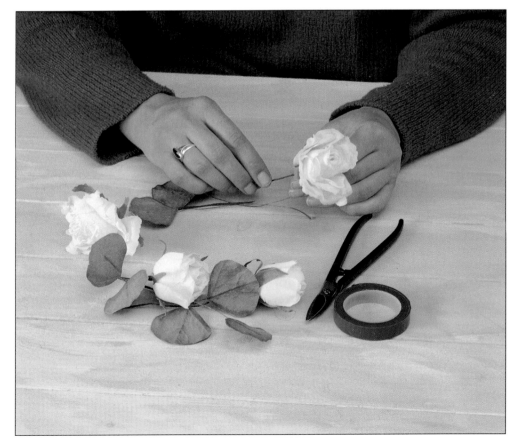

FESTIVE FUN

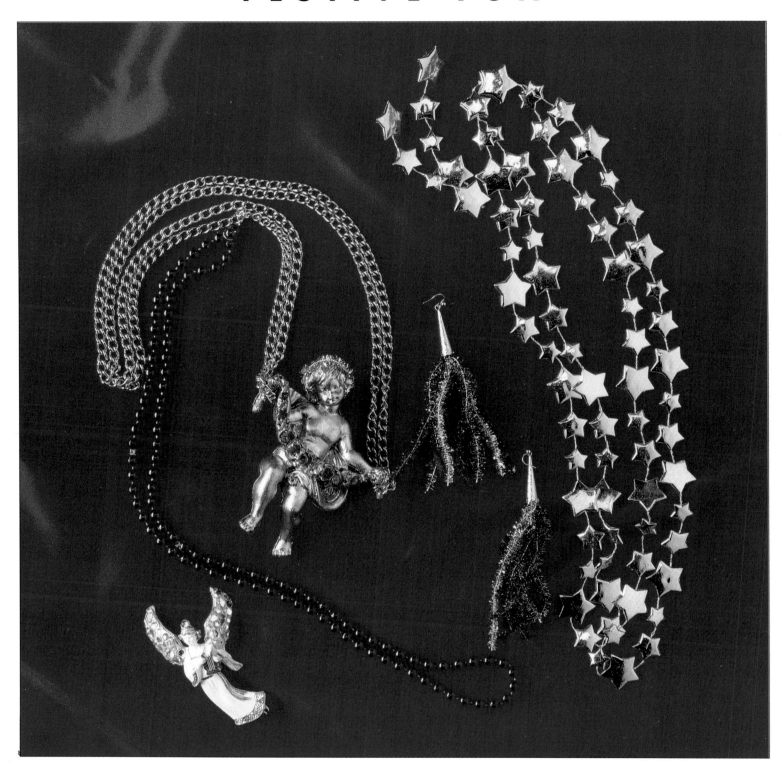

ABOVE

This picture shows fun festive jewellery. Long strips of Christmas star decorations are cut up and glued to form a necklace and earrings. A cherub has been painted with gold paint, the garland painted green and red, a tinsel halo glued on, and hung on a chain. The angel brooch is painted white and gold and her wings decorated with glass stones pushed into two-part modelling clay (see also page 20 et seq.). Also shown are earrings fabricated from tinsel tassels.

FESTIVE FUN

Materials

For this project you will require brass tag ends (cone), eye pins, earring wires, thin wire, tinsel and clear adhesive, from craft/hobby shops. You will need star sequins from dress-making suppliers, and a pair of round-nosed pliers.

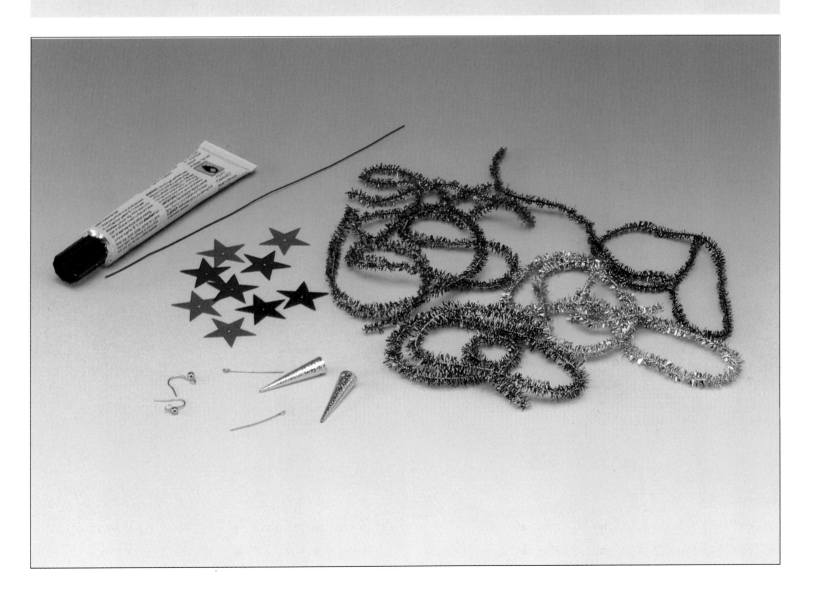

TINSEL EARRINGS

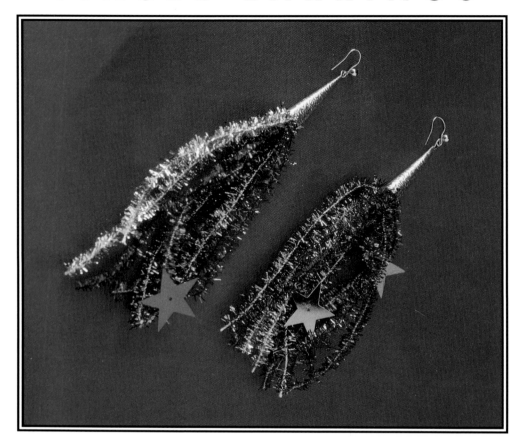

1 *Cut lengths of coloured tinsel twice the required length of earring.*

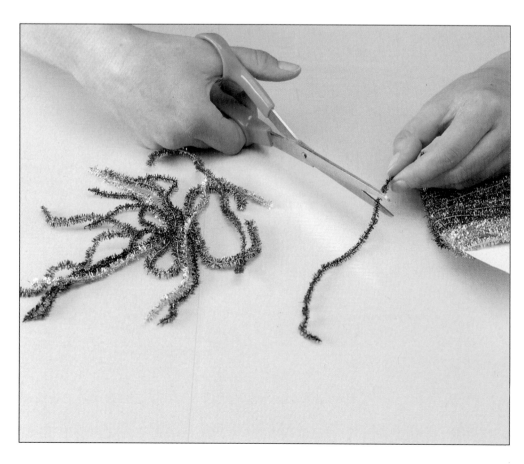

TINSEL EARRINGS

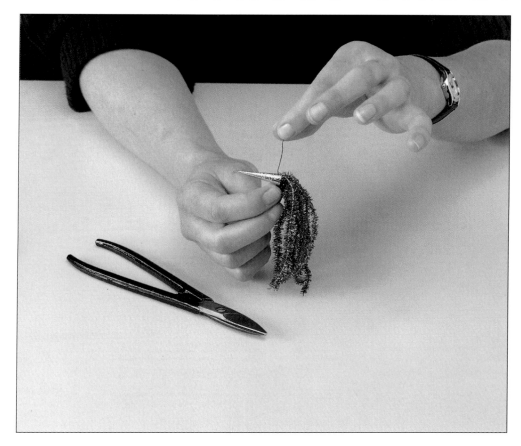

2 Fold over each length at centre and bunch together. Bind with fine wire to form a tassel.

3 Push looped wire up through centre of cone and make a loop at the top using pliers. Push tassel into cone and slide wire through hole on one side of cone, through tassel and out of opposite side of the cone. Cut wire to length, bend over edge of cone to hold tassel in place. Glue on coloured sequin stars. Fasten ear wires through top loops.

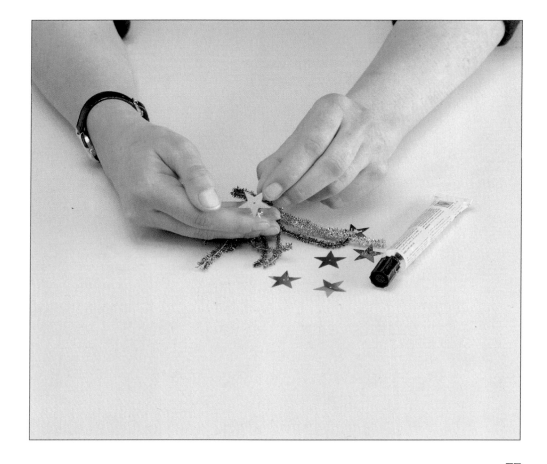

TEMPLATES

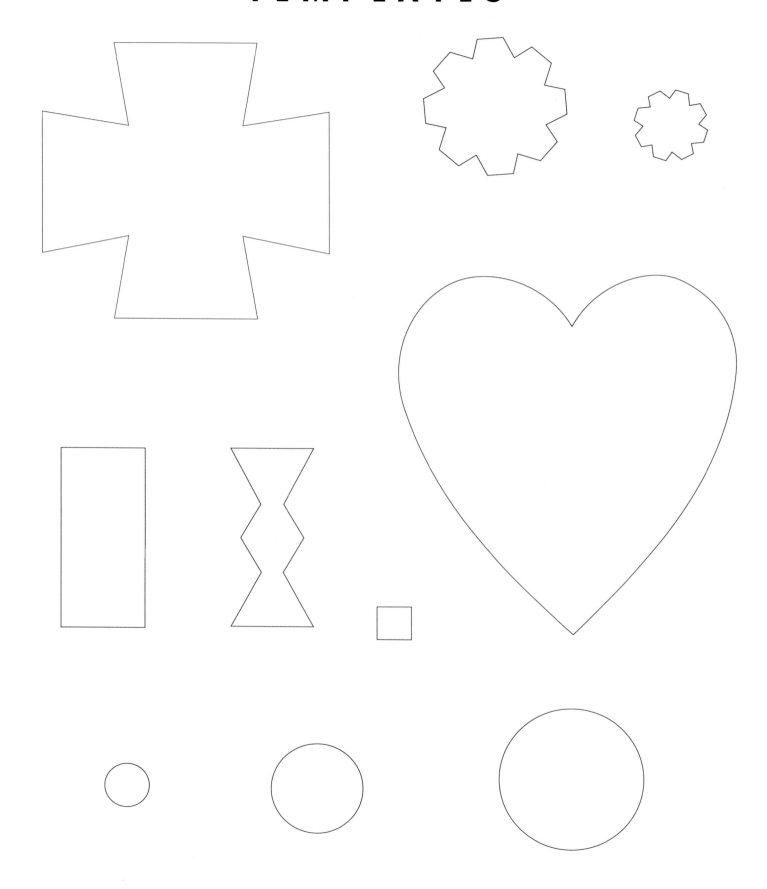

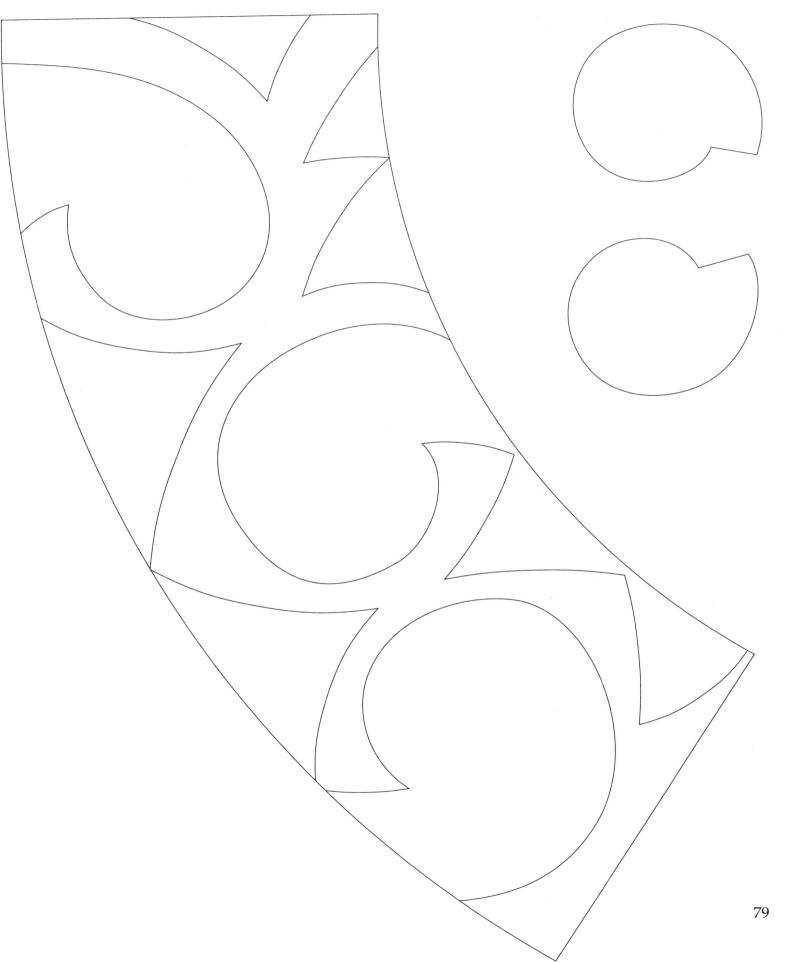

TEMPLATES & OTHER
USEFUL SHAPES

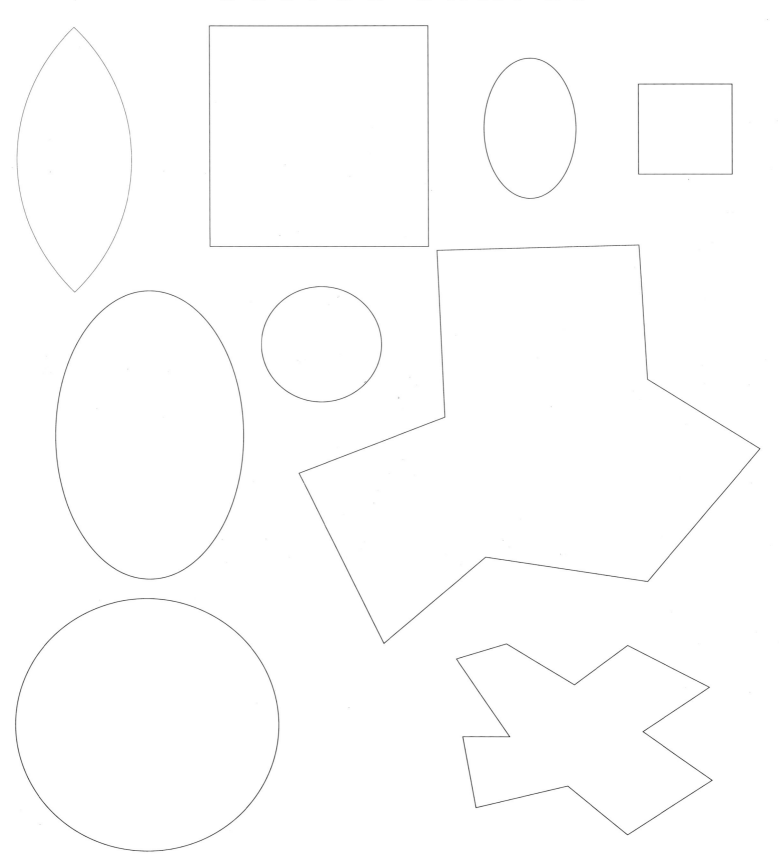